MOMENTS

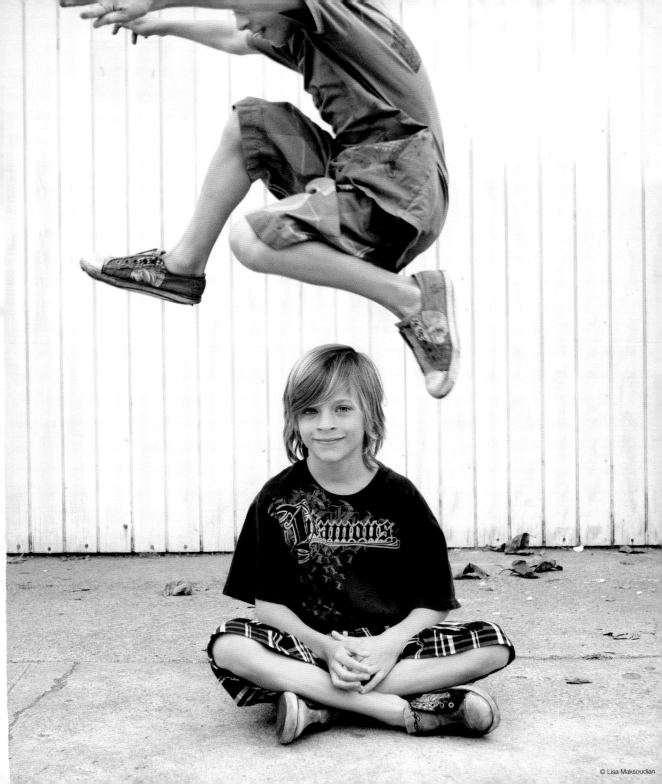

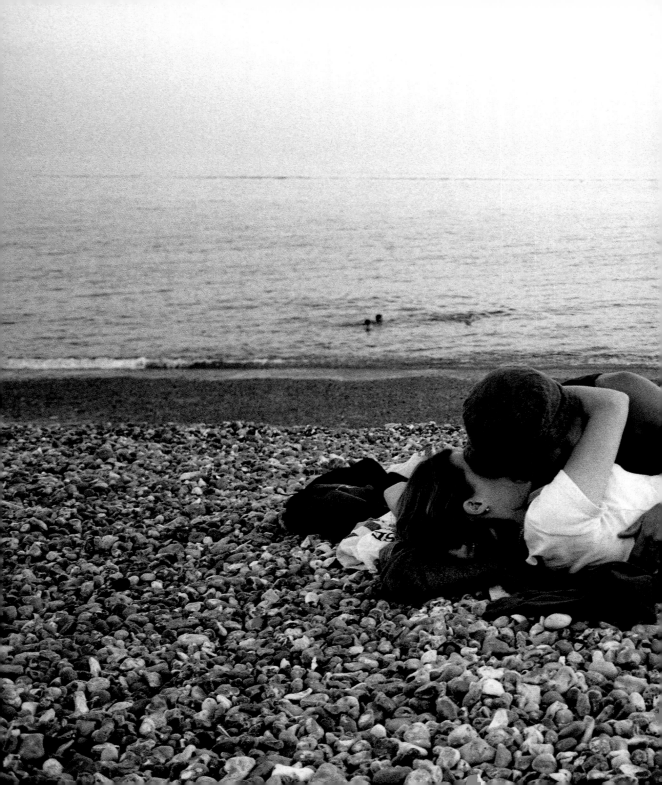

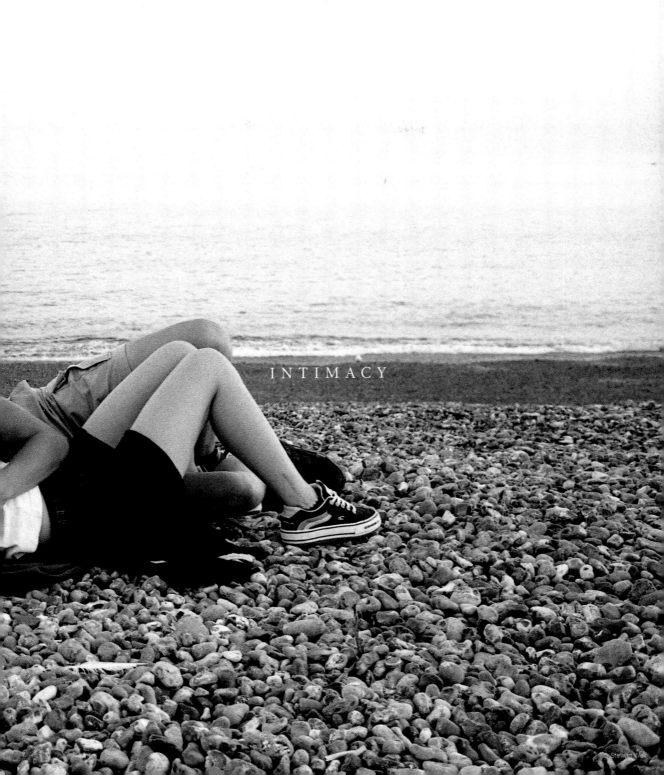

INTIMACY

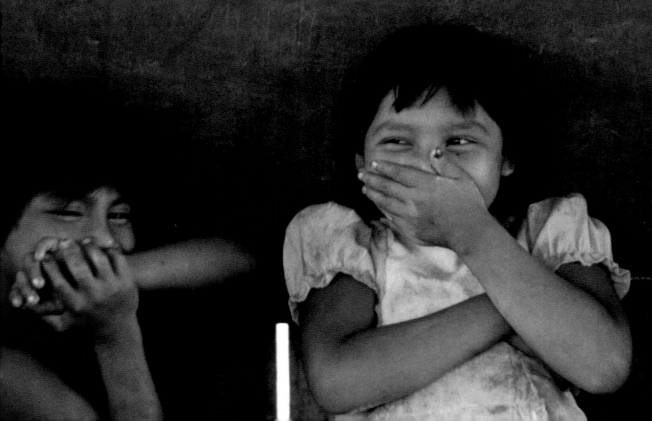

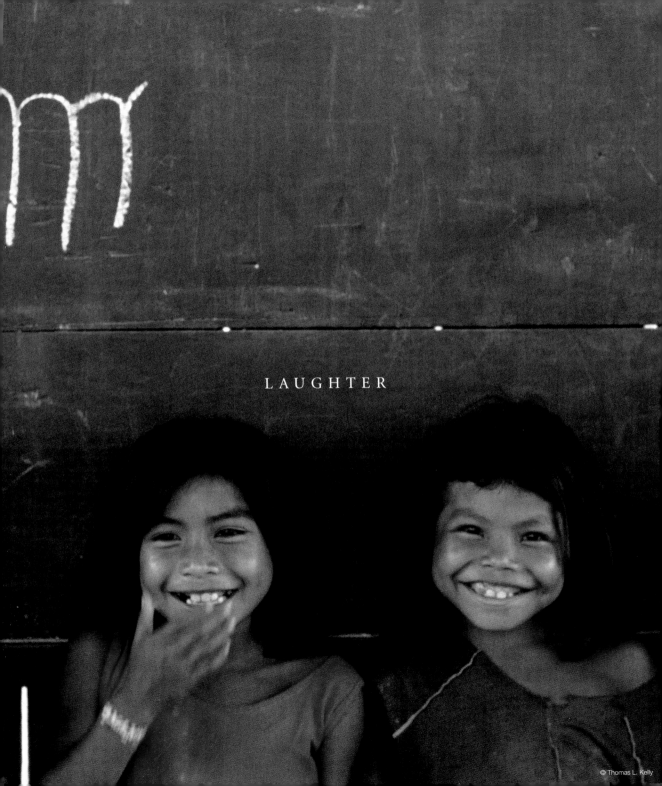

LAUGHTER

© Thomas L. Kelly

KINSHIP

HUMANITY

A celebration of
Friendship, Family, Love & Laughter

Edited by

Geoff Blackwell

PQ Blackwell
in association with

CHRONICLE BOOKS
SAN FRANCISCO

Twelve years ago I stumbled across a copy of *The Family of Man* at the MoMA bookstore in New York. It was the book of the landmark 1955 exhibition curated by Edward Steichen. I was immediately inspired by the global scale of Steichen's masterpiece, and I felt deeply moved by the images and their ability to transcend time and geography by virtue of their universal subject matter: the fundamental human capacity and need for love. I wondered what a collection of contemporary images would look like, and whether—almost fifty years later—it would be possible to piece together a comparable collection chosen from images from every country in the world.

With the benefit of youthful naivety, and equal measures of sincerity and enthusiasm, I embarked upon a journey toward finding out. With encouragement and advice from my family, friends, and colleagues, I developed a plan for a new collection called M.I.L.K. Support was sought from my visionary publisher-boss, Tim Hely Hutchinson, and two years later the project was launched in the form of an epic competition involving photographers from all of the world's 192 countries, and a world-record prize.

The scale of this "photographic event" was enormous, but the concept was simple: to search the globe for images that captured spontaneous human moments of intimacy, laughter, and kinship. Ultimately, the competition attracted over 40,000 entries from 17,000 photographers—Pulitzer Prize winners, leading professionals, and amateurs alike—from 164 countries. In a dedicated space we called the "Milk Shed," we accepted entries by the sackful. Some came as prints, some as negatives, some in handmade packages, most with stories; all somehow wrapped in the ephemera of human life.

The judging process took months and carried a heavy responsibility—how to choose one person's moment over another? With the help of some extraordinary colleagues, and, in particular, the legendary Magnum photographer Elliott Erwitt, we finally settled on 300 winning images that became the original M.I.L.K. collection.

It was first exhibited in New York on July 11, 2001, in the elegant yet egalitarian surrounds of Grand Central Terminal. Many of the photographers and some of the subjects of their pictures attended the launch from around the world to celebrate with us, and for a joyous night we were the family of man. It was one of the most extraordinary evenings of my life and it provided a very personal moment with my own family—one that I will treasure forever.

In the days that followed, many people walked through the maze of photographs we had constructed, and viewed the M.I.L.K. collection projected onto an immense screen. Some cried, others laughed. As they moved through the exhibition their shadows were cast onto the backs of other images, a subtle interplay of static image and movement. Here was humanity writ large and writ small, in the moments captured on film and in the people moving freely around them. Moments were exhibited and moments were experienced.

In a bitter irony, the same space in Grand Central Terminal that housed the M.I.L.K. exhibition was used as an emergency blood bank on September 11, just two weeks after the exhibition closed. Though there would ultimately be little requirement for their donations, people queued to give blood to assist their fellow New Yorkers. The poignancy of this event is at the core of M.I.L.K. and what it represents: our need to believe that there is something that unites us all as humans, something intrinsic within us that urges us to give selflessly, love generously, and live without regret.

This brief retelling of M.I.L.K.'s history provides a neat veneer over the reality that the journey leading to its creation was not without moments of despair and significant financial difficulty. We always said we'd never do it again, but projects as enriching and rewarding as M.I.L.K. are hard to find, and as the tenth anniversary of the original competition approached we simply couldn't resist the challenge and attraction of seeking to create another collection.

We announced the Fresh M.I.L.K. competition in August 2008, and in contrast to the original competition we conducted it entirely via the World Wide Web. After nearly ten years, it was with considerable anticipation that we downloaded the first batch of images in January 2009, and began the judging process. Unlike the entries received a decade ago, there could be no lovingly stitched cloth packages. But they came to us packaged in different ways, wrapped in words, seeming to carry with them the subtle fragrance of people and places close by and far away.

With the technological advances of the last ten years it was a surprise to see that so many of these new images had been shot in black and white. Subtle and classical, the black-and-white image stands resolute as the favorite medium for M.I.L.K.'s photographers. Could it be something to do with the way it strips unnecessary color from compositions and makes us look closer? The way it emphasizes hard-earned wrinkles, sets shadows into dimples, dances light upon smiles and delineates emotion?

Among the entries were some familiar names—those of previous M.I.L.K. contributors, their new entries marking the passage of time. M.I.L.K. contributor and Pulitzer Prize winner John Kaplan's entry struck a personal chord for me: a self-portrait taken to celebrate the remission of his cancer; the thick hair he wore at the M.I.L.K. launch now lost, but his spirit indomitable.

This time Elliott Erwitt had the sole responsibility of choosing an ultimate winner: one image that encapsulated Fresh M.I.L.K. On pages 20–21 you can view his choice by Victoria Vaisvilaite Skirutiene from Lithuania. Candid, yet beautifully composed, it captures a private moment shared between a father and his daughter as he seeks to lighten her mood during a break in a long journey from Lithuania to Russia in a camper van.

*

This new collection celebrates the tenth anniversary of M.I.L.K. But it does more than that. Through the lenses of nearly 150 photographers, *Humanity: A celebration of Friendship, Family, Love, & Laughter* not only continues, but expands the experience that was M.I.L.K. It is both a celebratory sequel and a self-determined and independent reassertion of humanity's enduring capacity for intimacy, laughter, and kinship.

The images here are effusive, poignant, and far-reaching, yet, ultimately, incredibly intimate. Their extraordinary power comes, ironically, from their very ordinariness. They speak a common language punctuated by casual gesture, exquisite tenderness, and natural insouciance.

I have learned many lessons through the journey that has been M.I.L.K., the most profound of which has come through the process of assessing the previous decade. In the last ten years of my life the personal moments that stand out are those I have shared with the people I love. Ultimately, through the course of any life, it is love that survives, nurtures and endures.

I salute all of the men and women—the brilliant and generous photographers from all corners of the globe—who have shaped this project. We feel privileged to publish your work, and we have done our best to honor it with this book. I wish to express my gratitude to my wife, Susanna, and to my family, friends, and colleagues who have traveled the road with me since M.I.L.K. was just a dream. I am particularly grateful to Elliott Erwitt, who once again gave generously of his expertise and experience by choosing the first-place winner; to Jacqui Blanchard, whose talent and professionalism have made staging a world photography competition look easy; to Don Neely for his friendship and help during the judging; to Cameron Gibb, the ultimate designer of exquisite books; to my brother Paul and to Ruth Hobday, my ever-generous partners who support me and keep our company afloat in different ways everyday; and, finally, to the myriad others who have contributed to M.I.L.K. throughout the years, including you as you turn these pages: all these moments of intimacy, laughter, and kinship belong to you.

Geoff Blackwell, April 2009

Ultimately,
through the course of
any life, it is
love
that survives,
nurtures and
endures.

The future
belongs to those
who believe
in the beauty
of *their*
dreams.

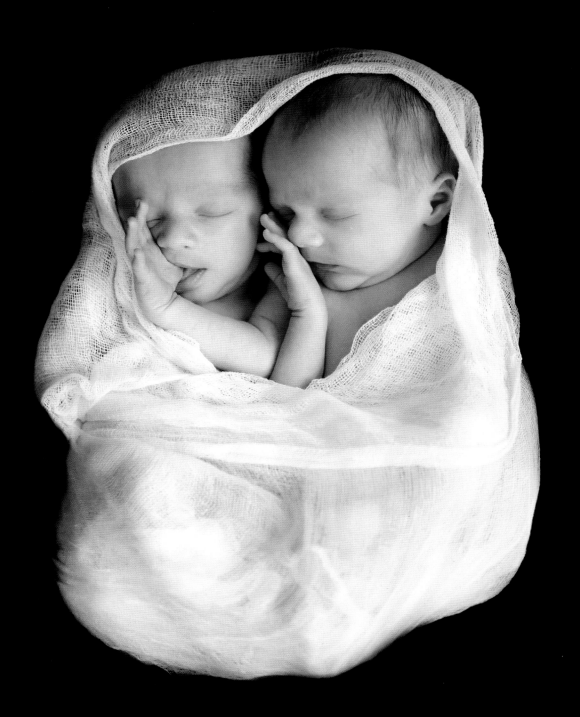

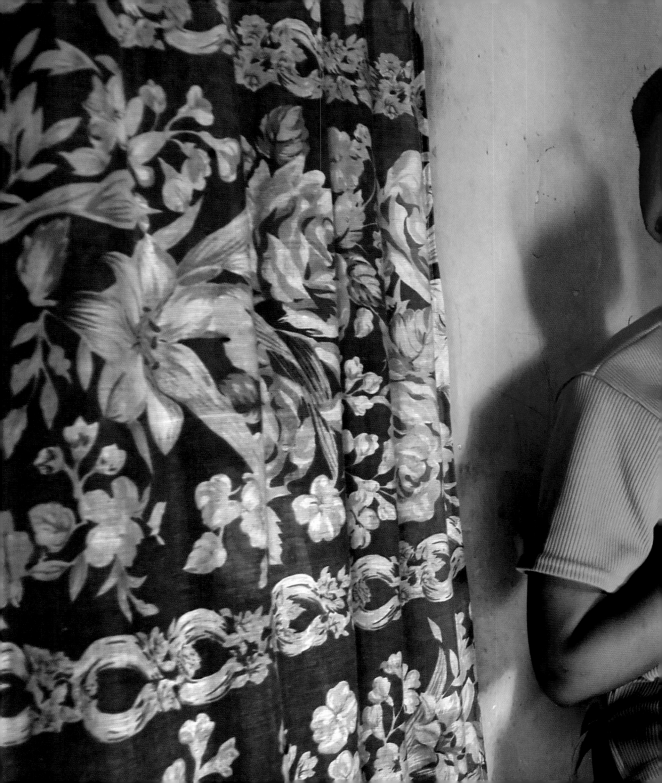

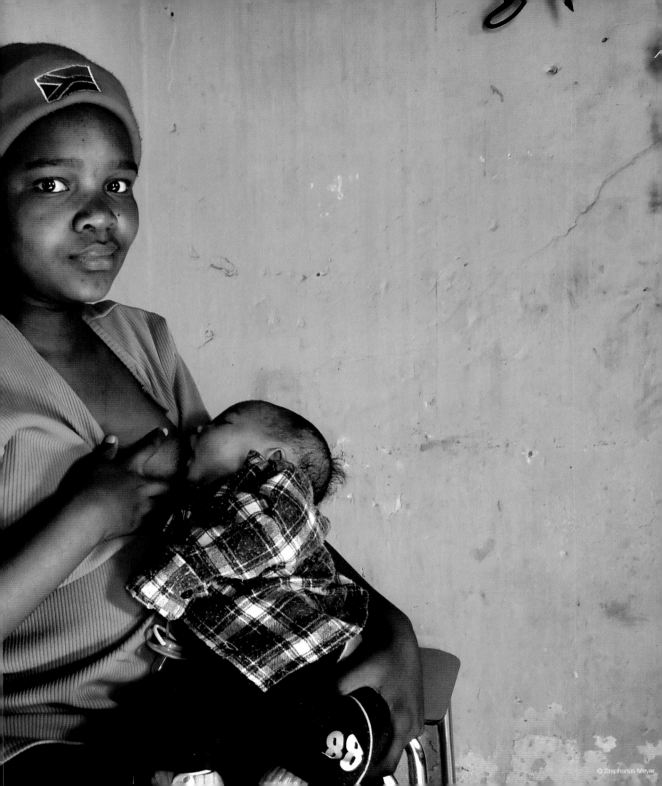

The life and
love
we create is the
life
and love *we live.*

Leo Buscaglia

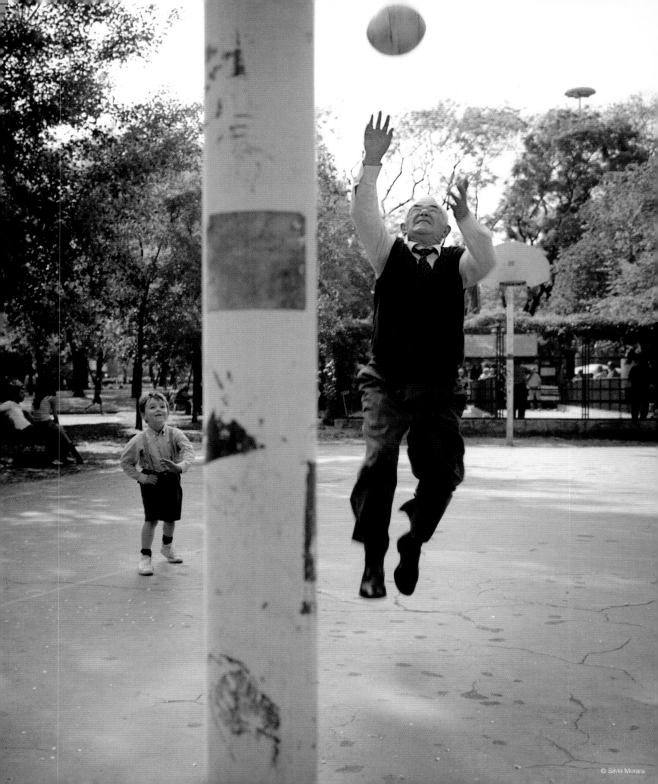

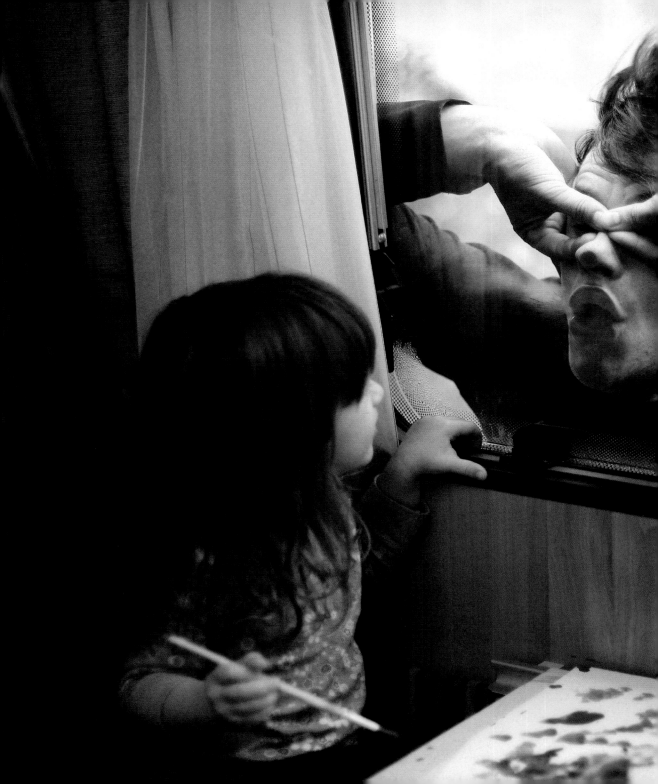

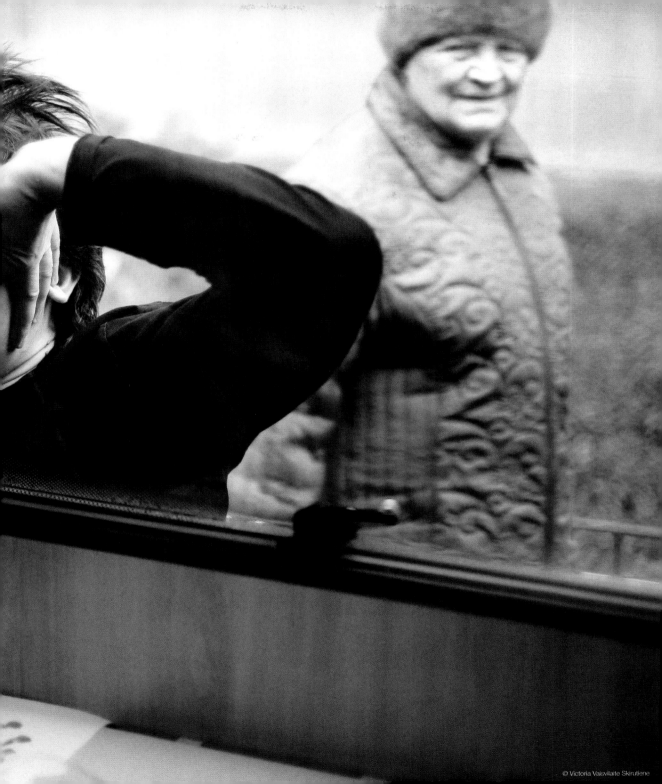

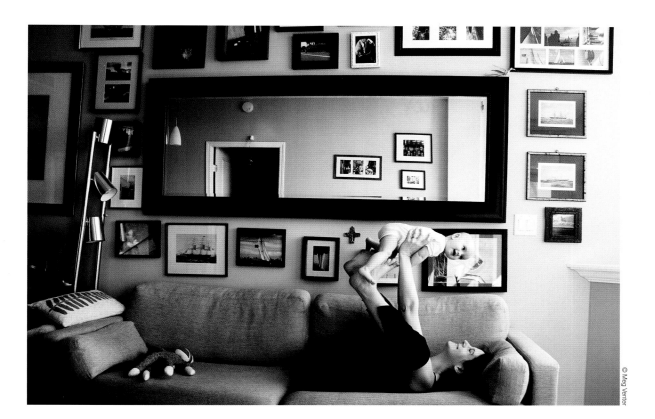

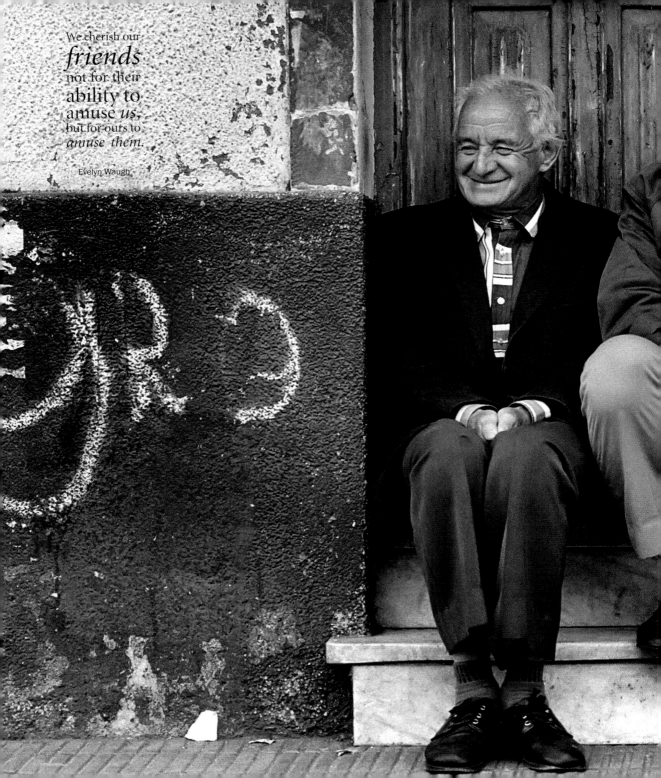

We cherish our
friends
not for their
ability to
amuse *us*,
but for ours to
amuse them.

Evelyn Waugh

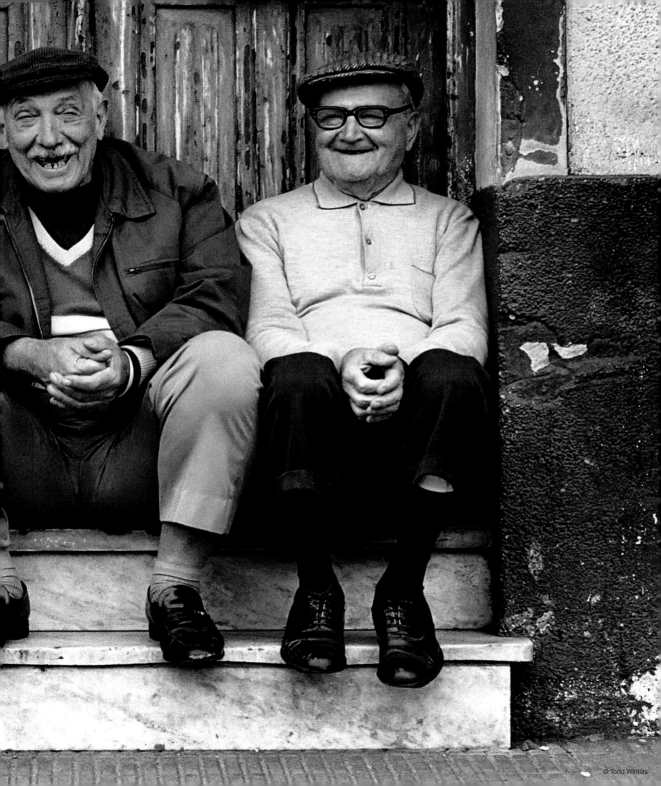

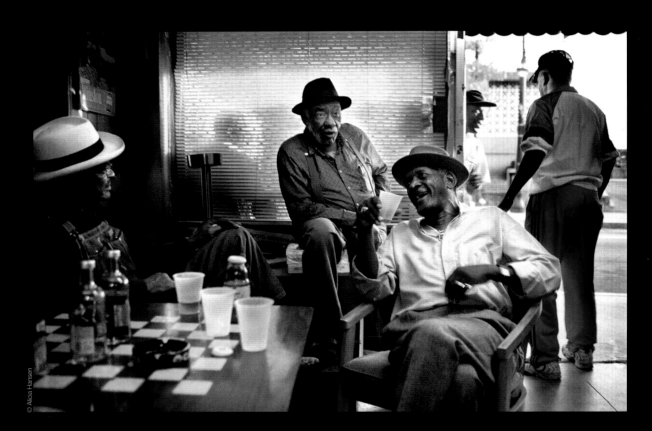

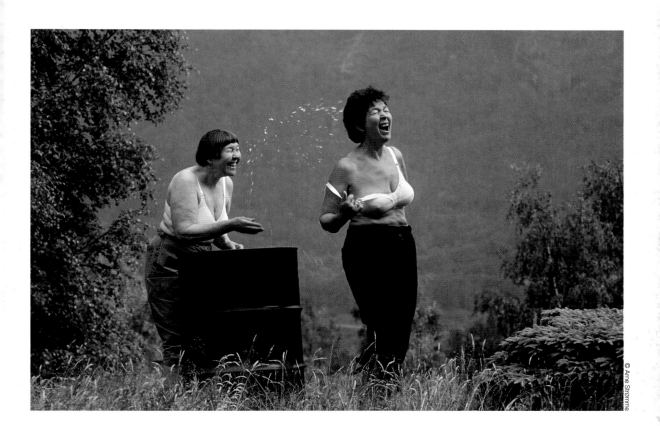

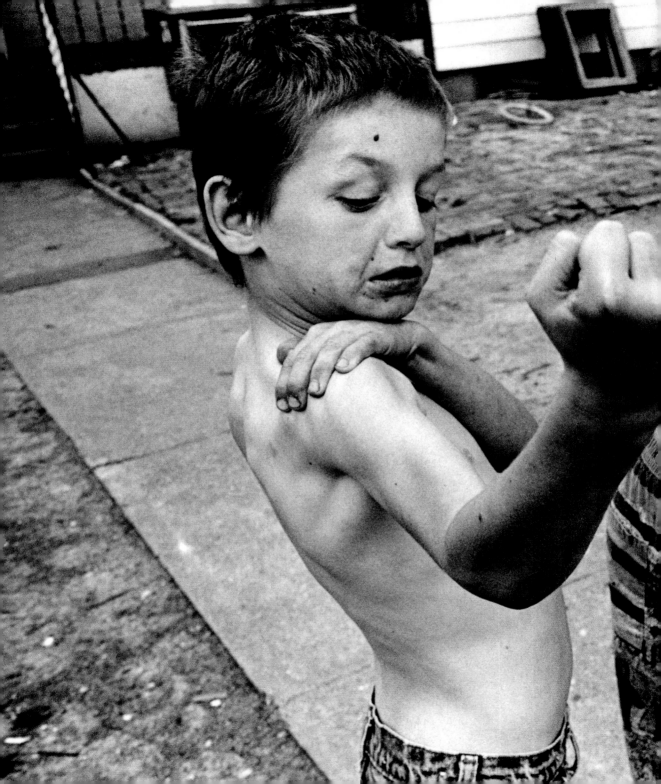

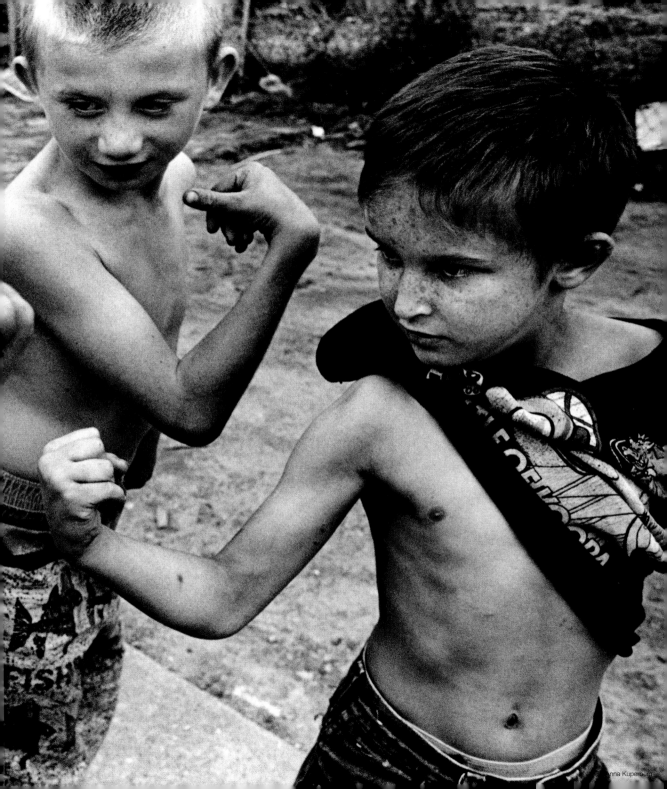

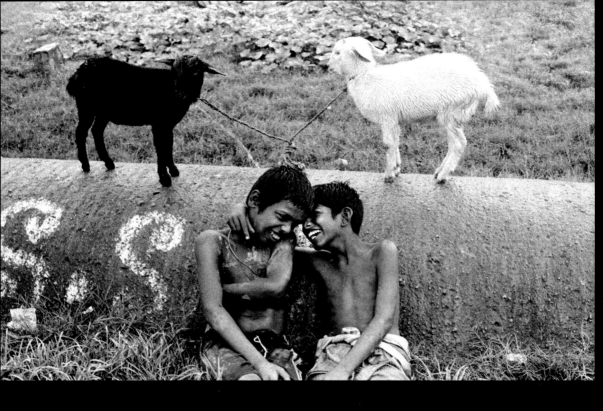

The most I can do for
my friend
is simply be
his *friend*.

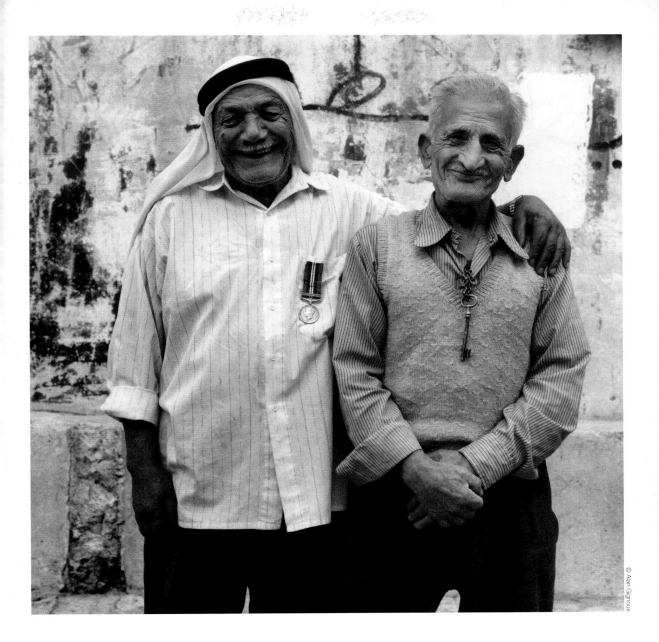

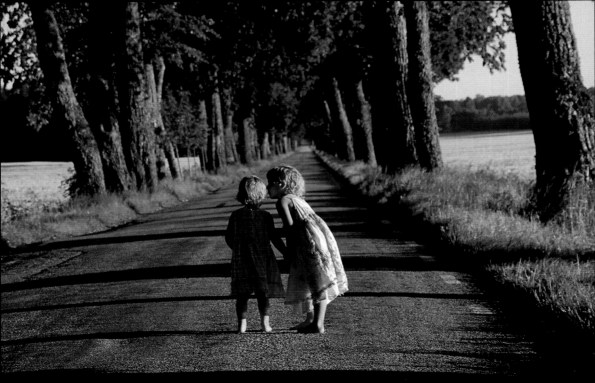

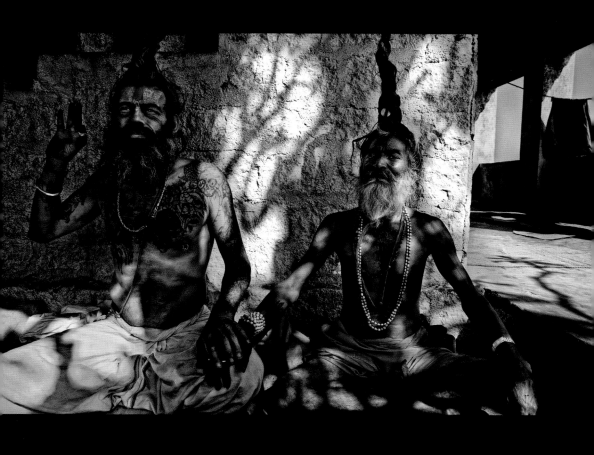

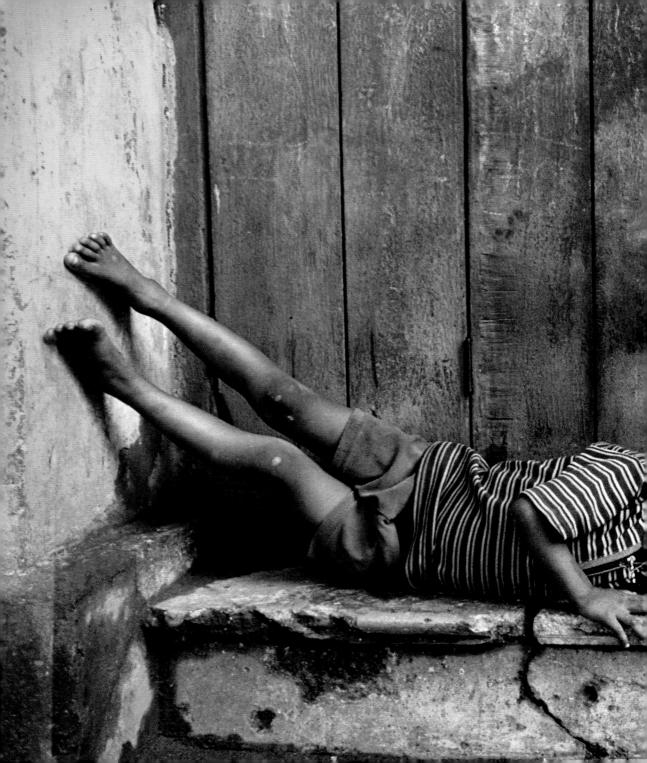

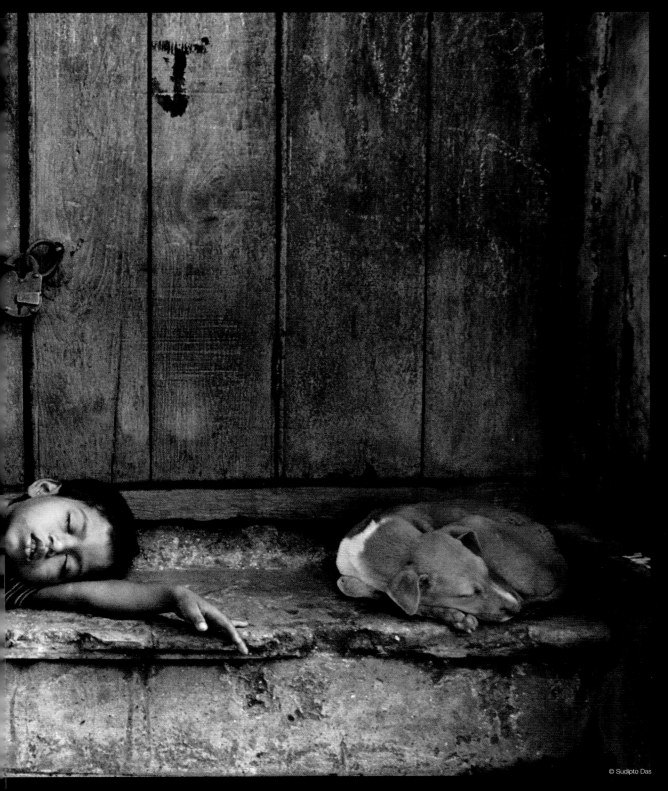

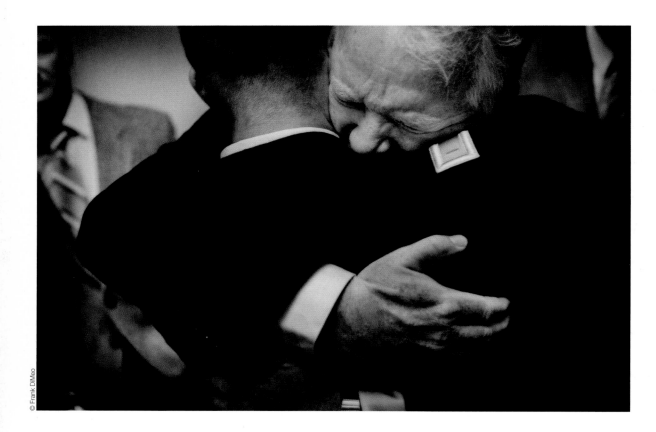

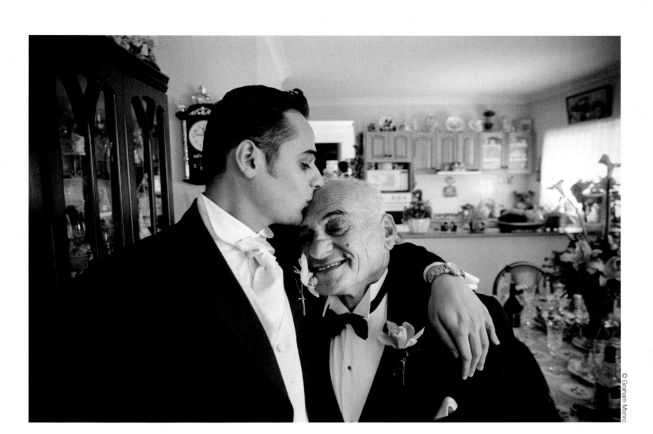

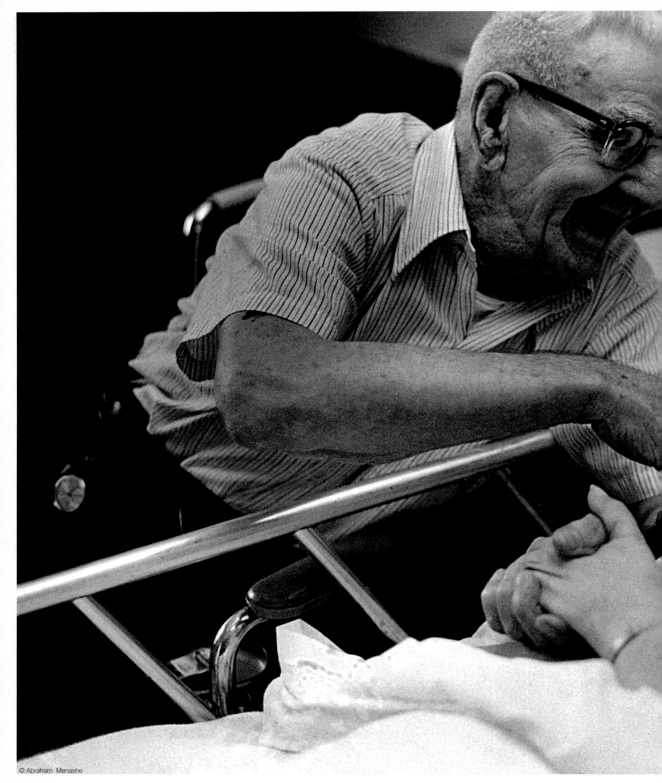

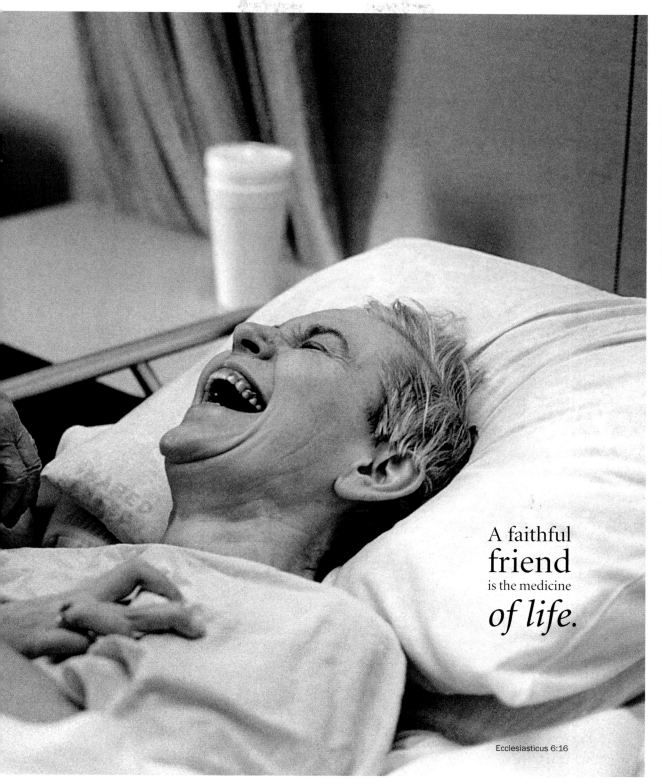

A faithful
friend
is the medicine
of life.

Ecclesiasticus 6:16

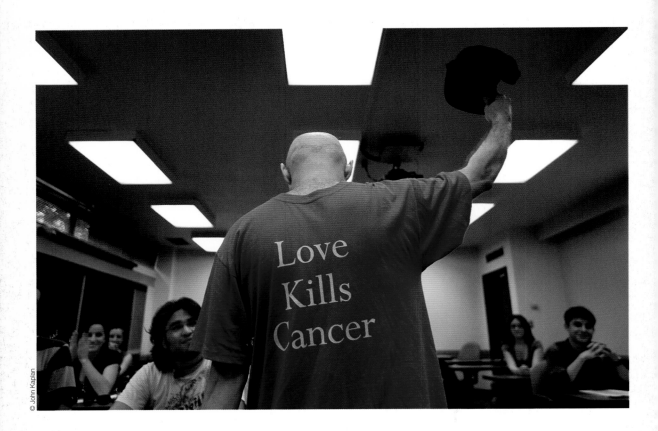

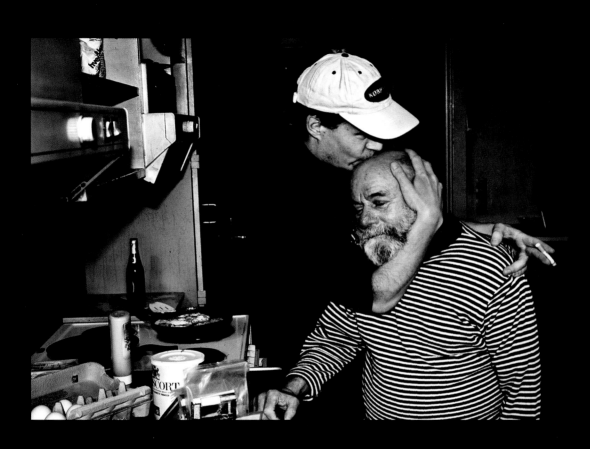

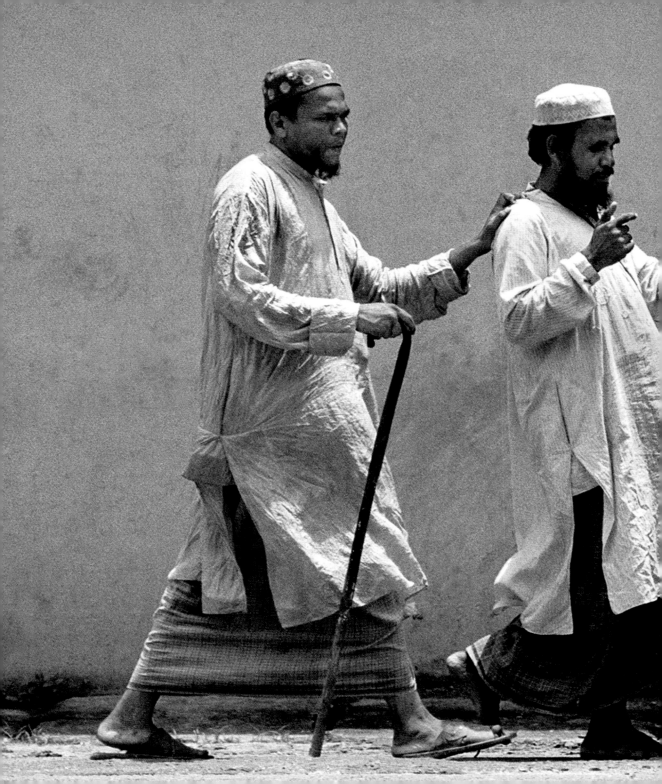

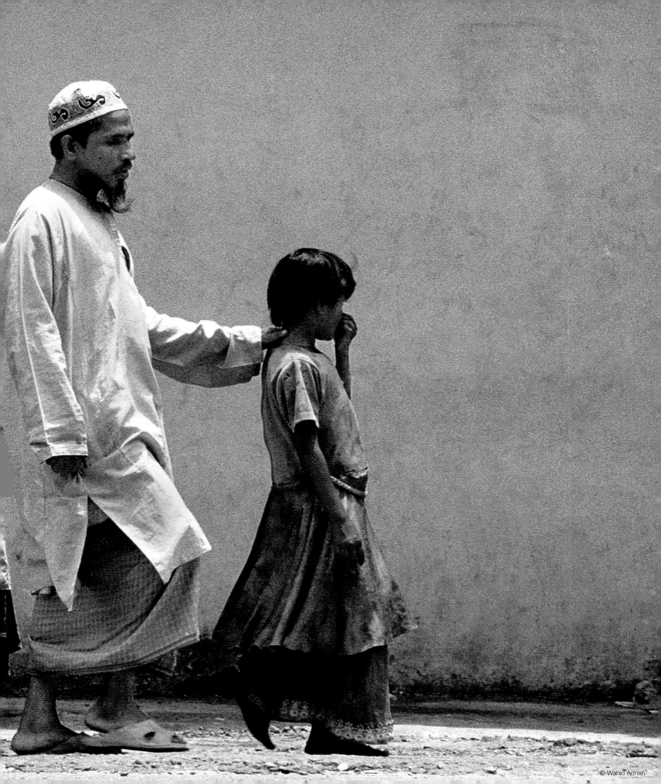

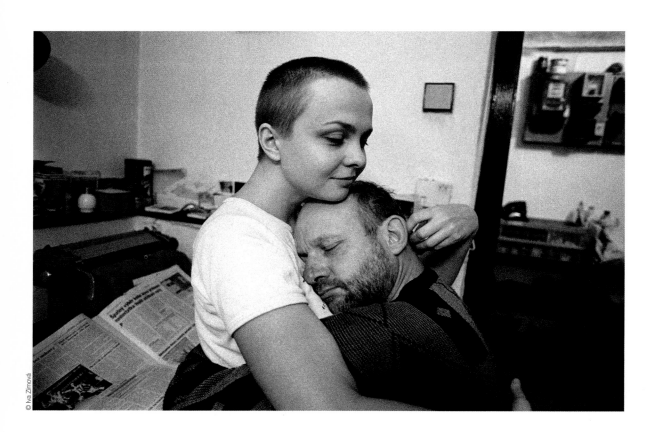

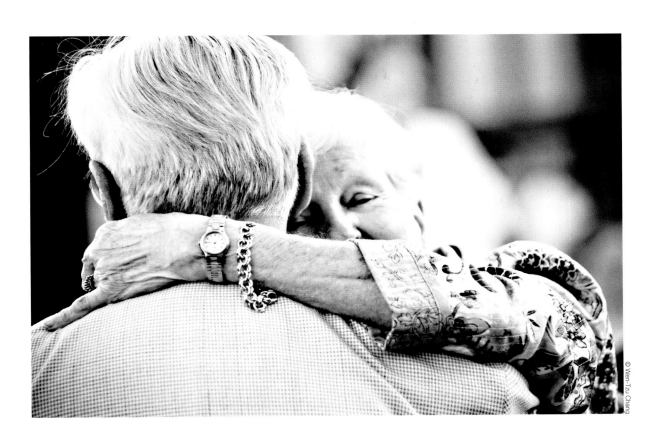

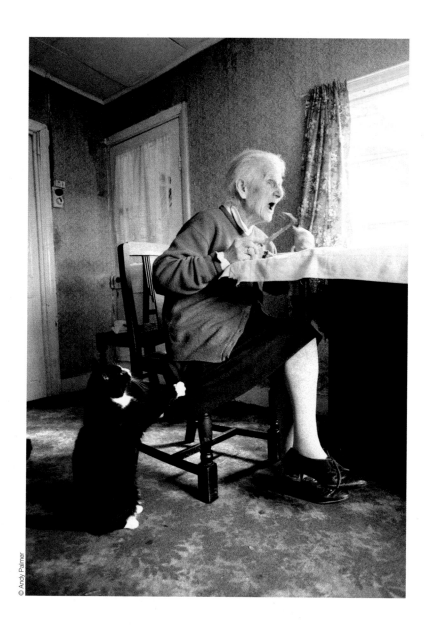

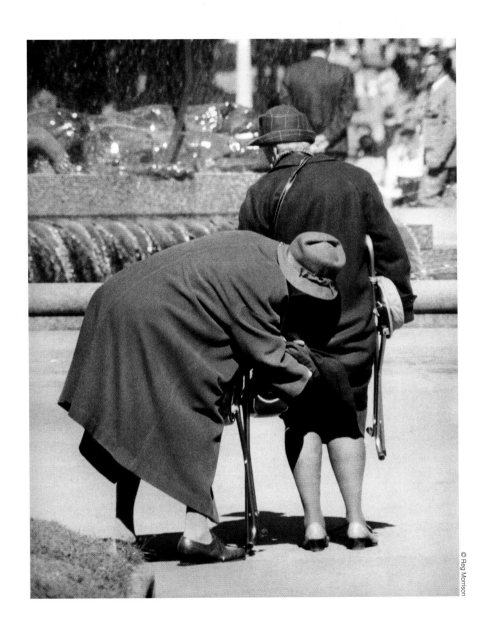

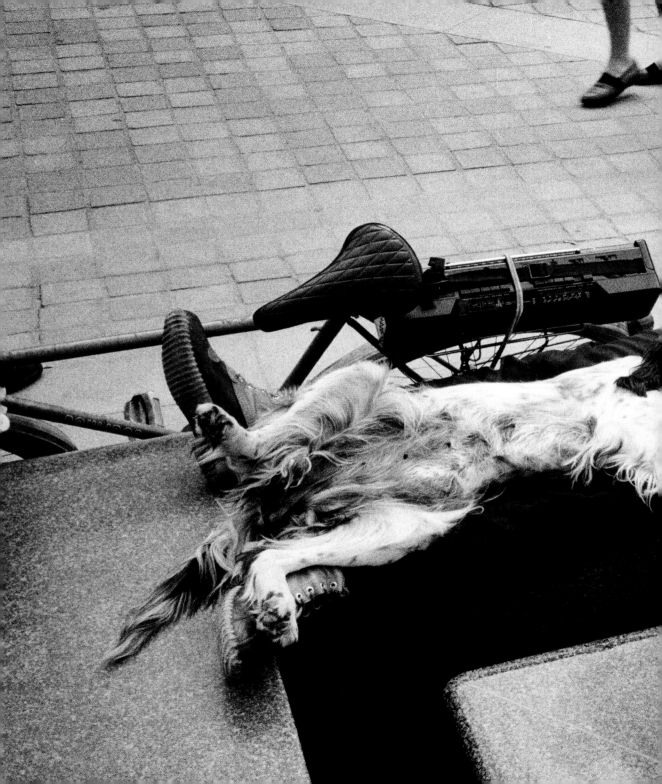

We talk of
choosing our
friends,
but friends are
self-elected.

Ralph Waldo Emerson

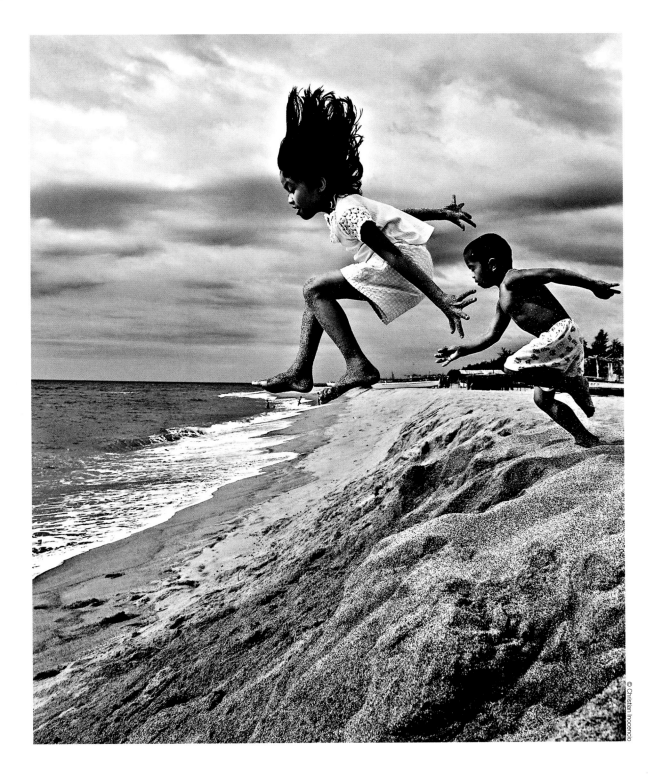

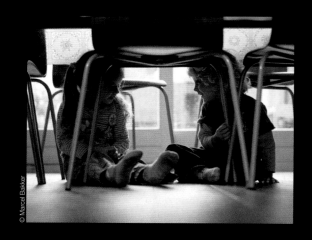

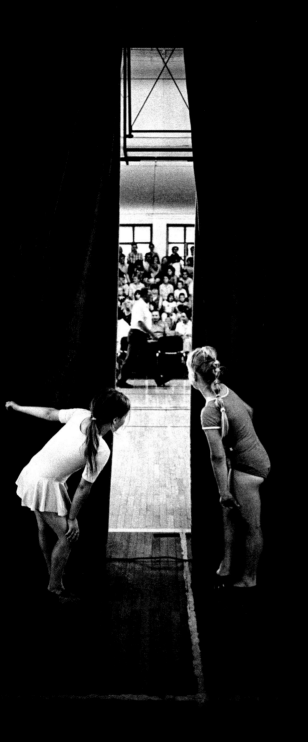

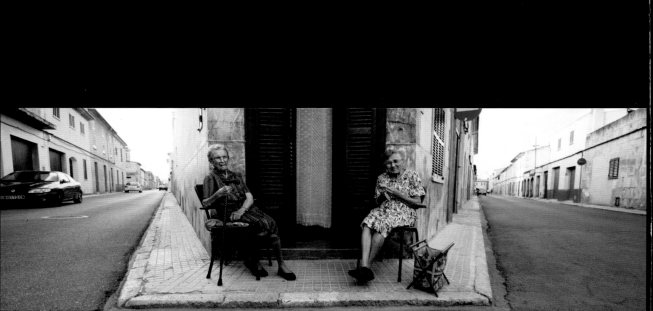

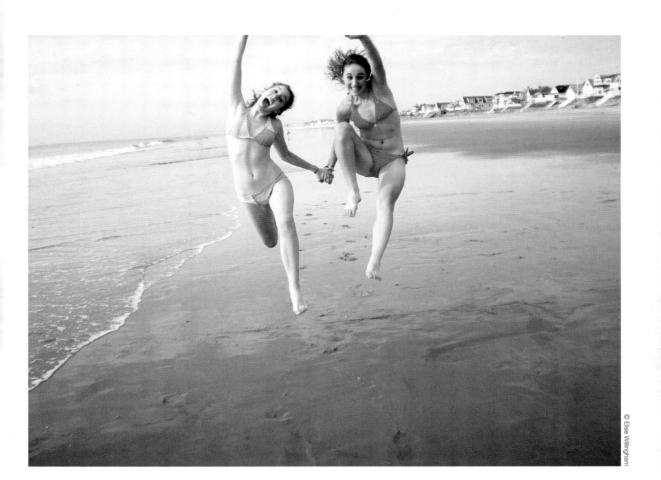

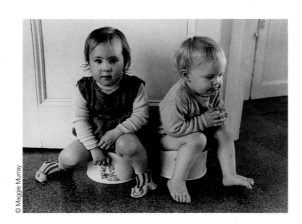
© Maggie Murray

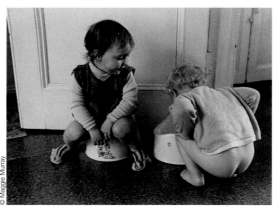
© Maggie Murray

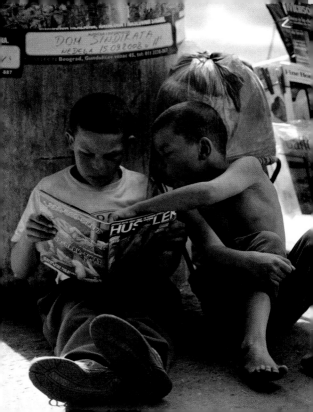

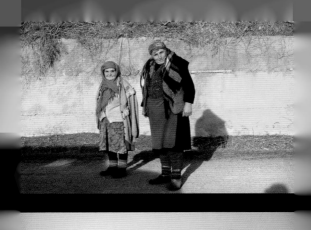

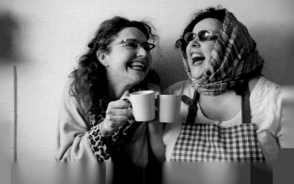

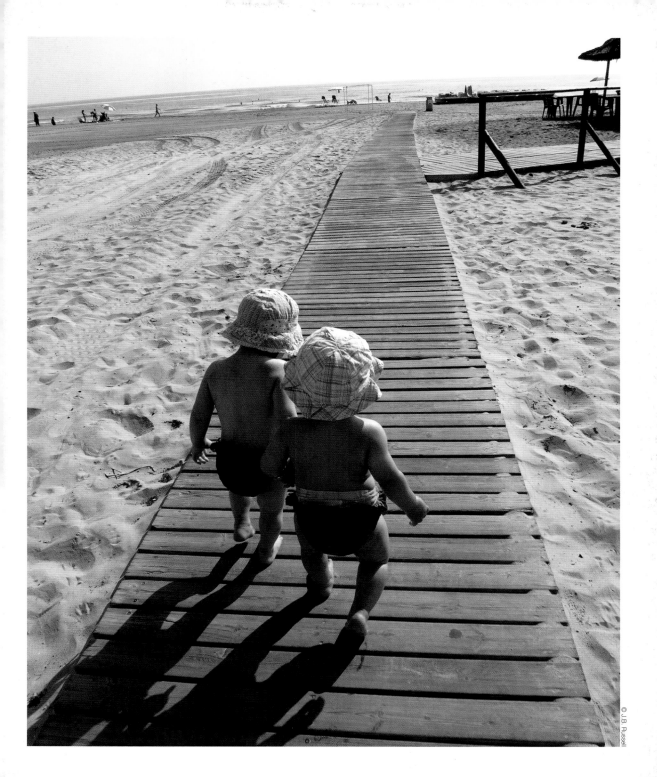

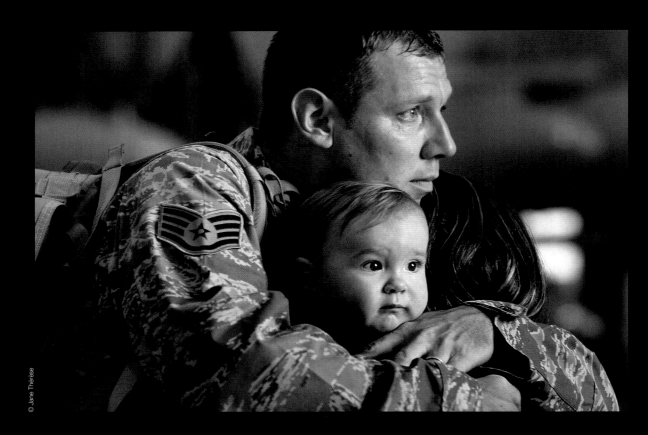

Where we
love
is home,
home that our feet
may leave,
but not our
hearts.

Oliver Wendell Holmes

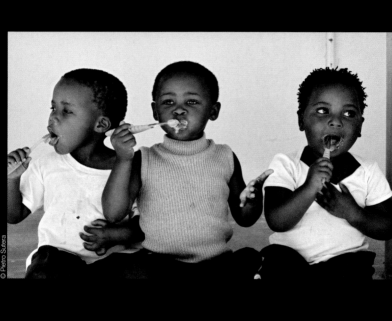

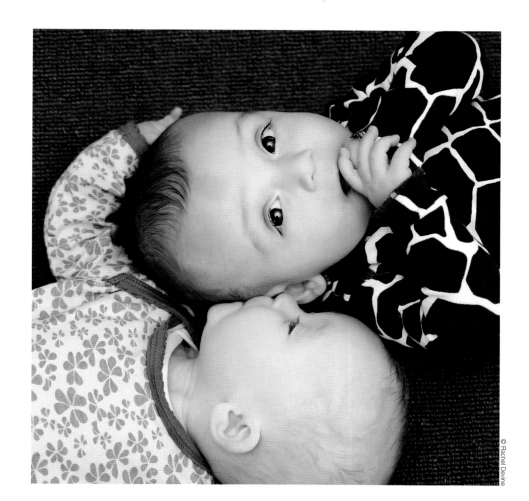

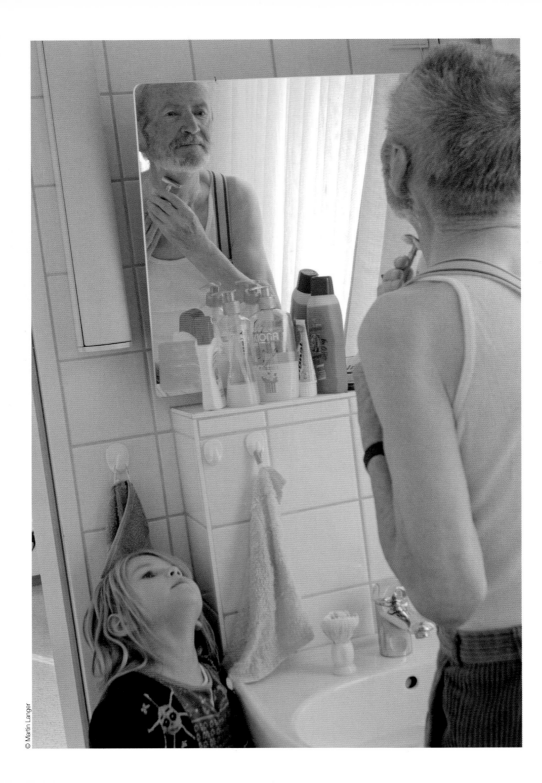

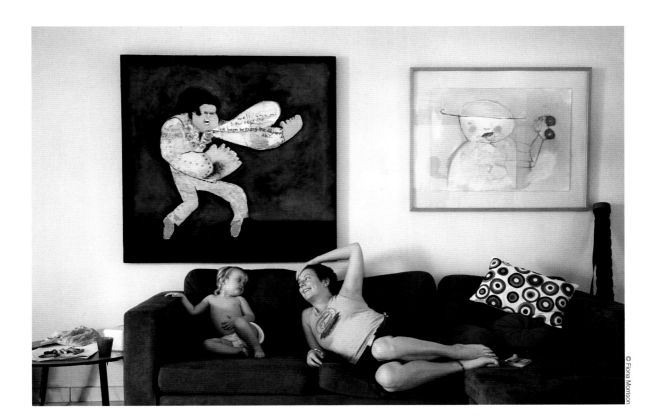

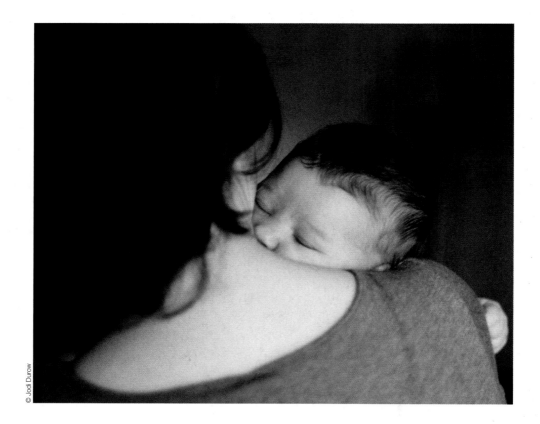

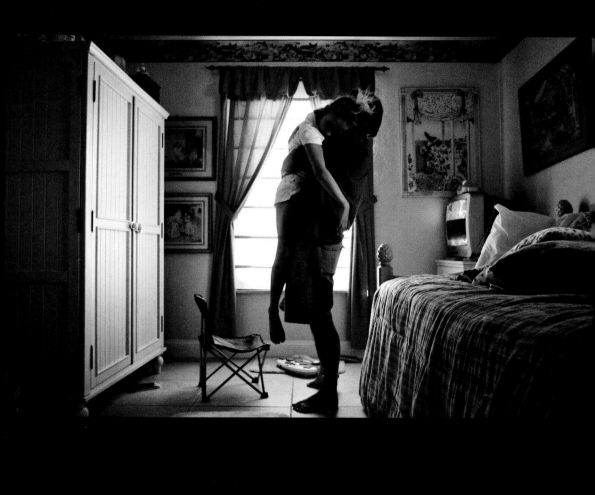

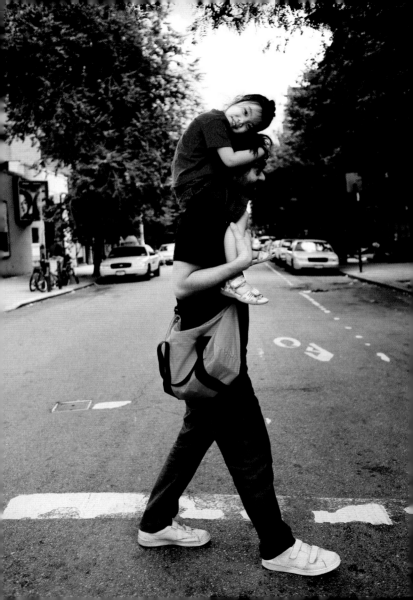

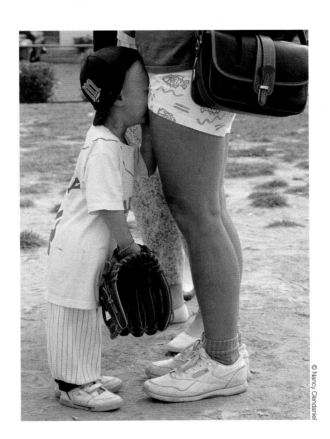

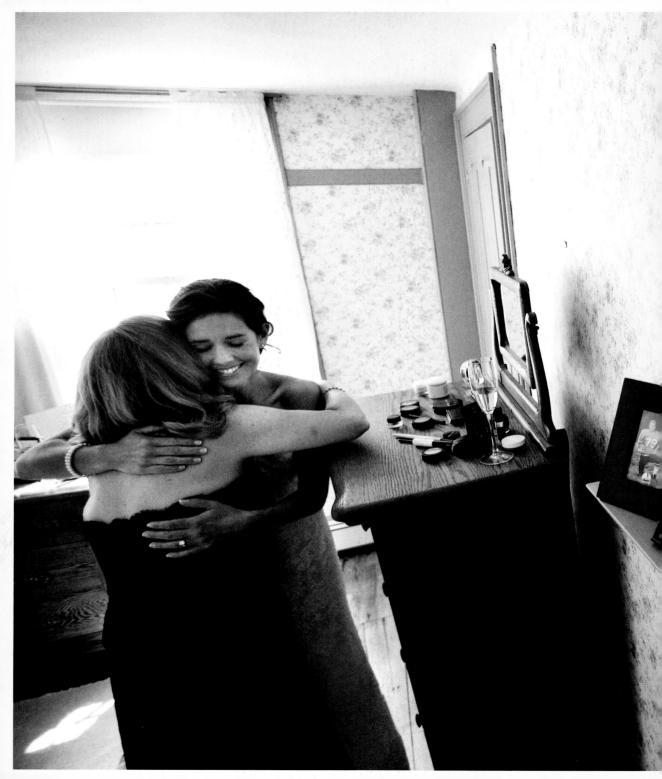

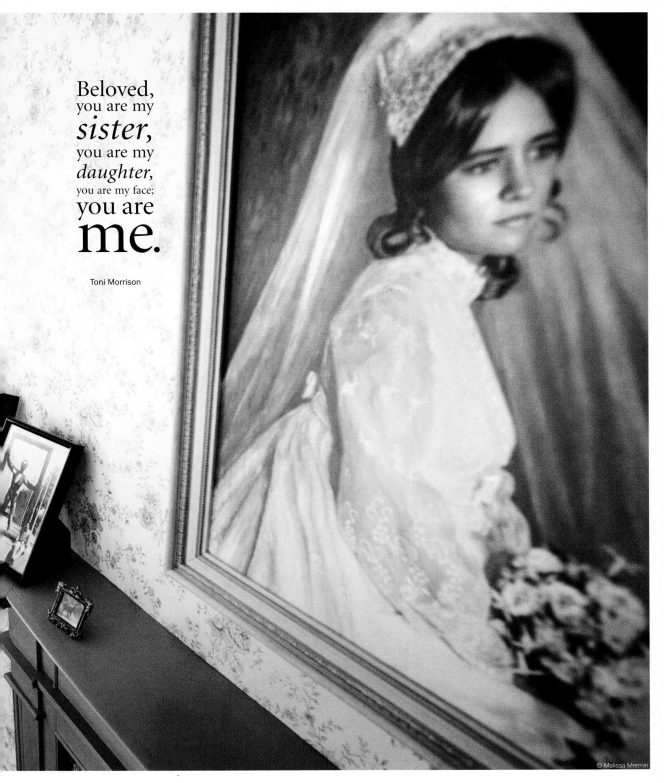

Beloved,
you are my
sister,
you are my
daughter,
you are my face;
you are
me.

Toni Morrison

© Melissa Mermin

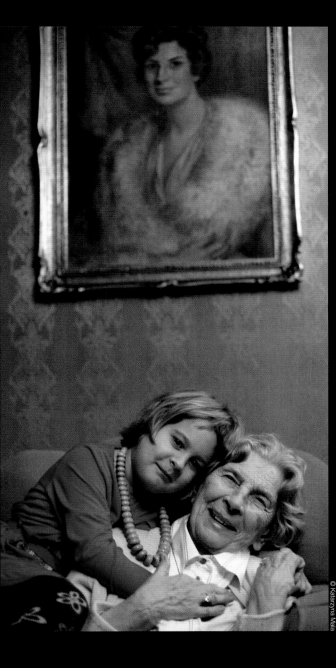

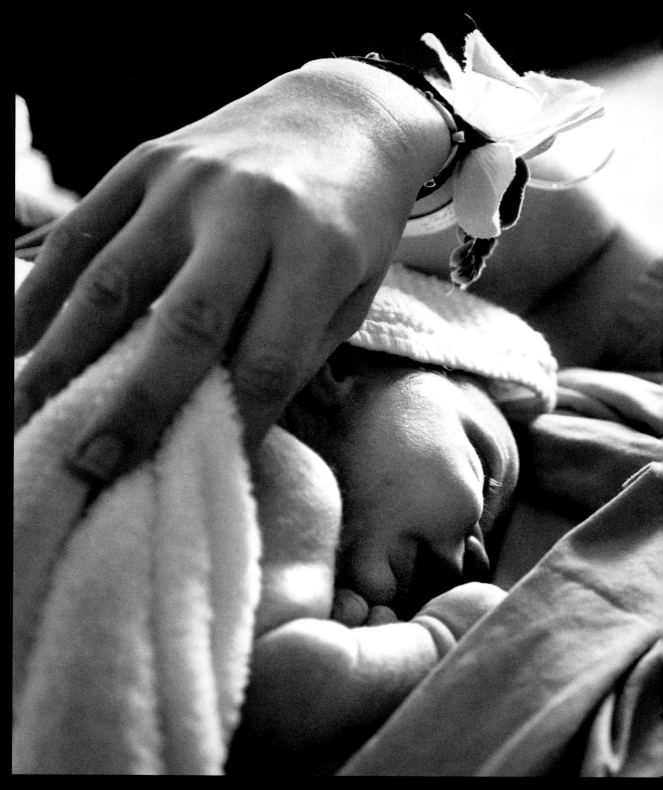

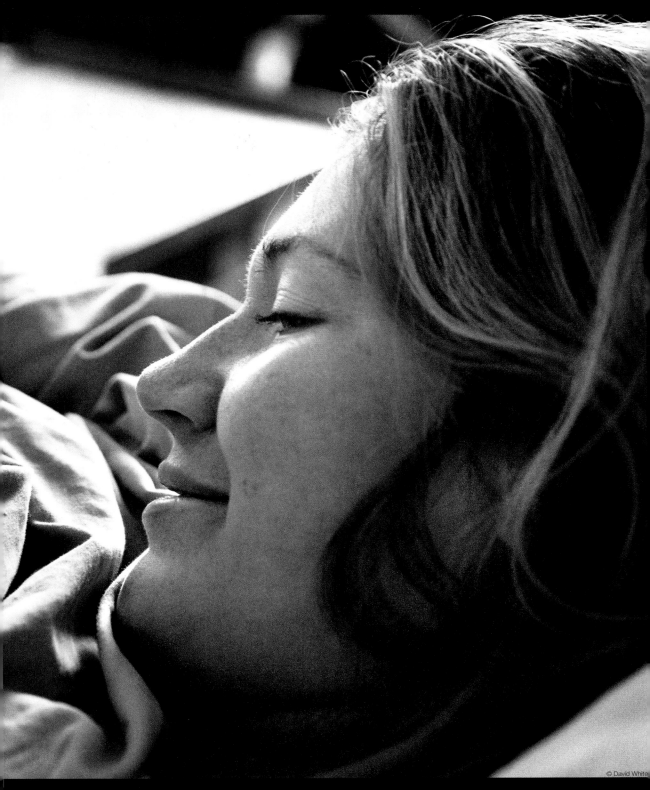

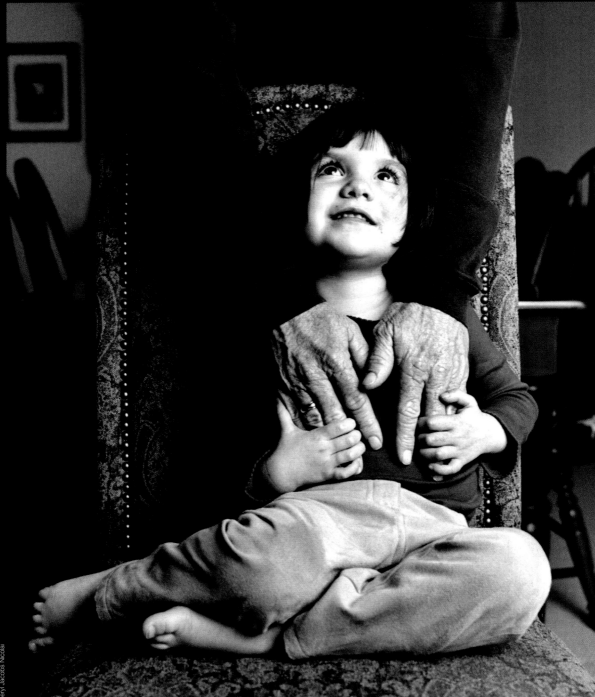

Love
conquers
all
things; let us too
surrender
to love.

Virgil

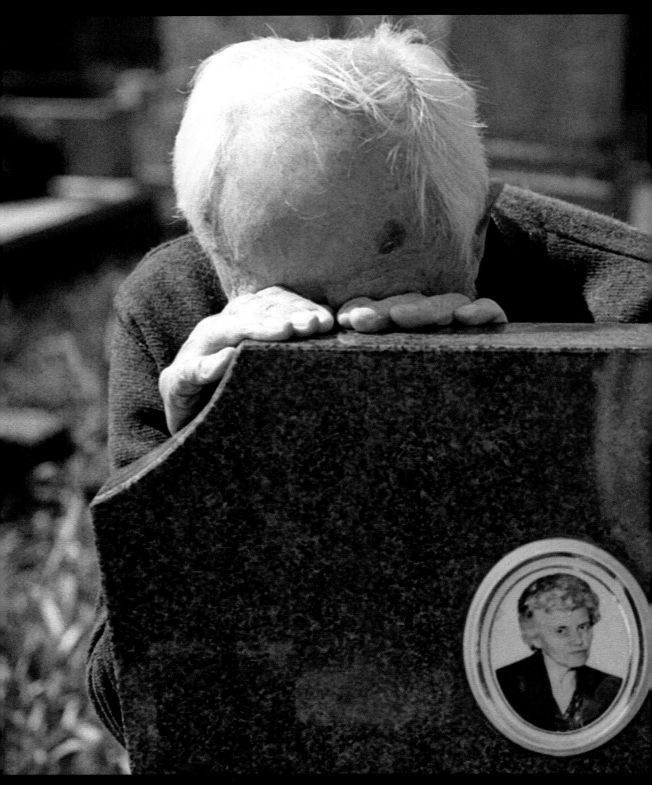

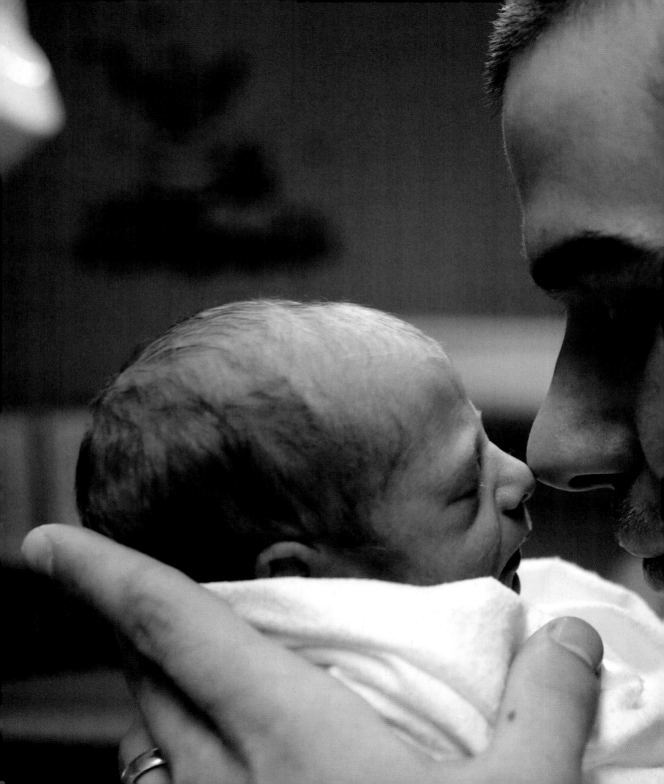

It is the absurdity

of family life, the

raggedness

of it, that is at once
its redemption and its

true

nobility.

James McBride

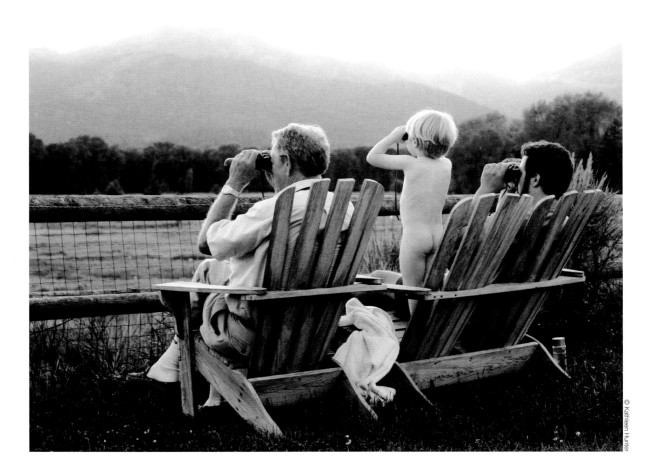

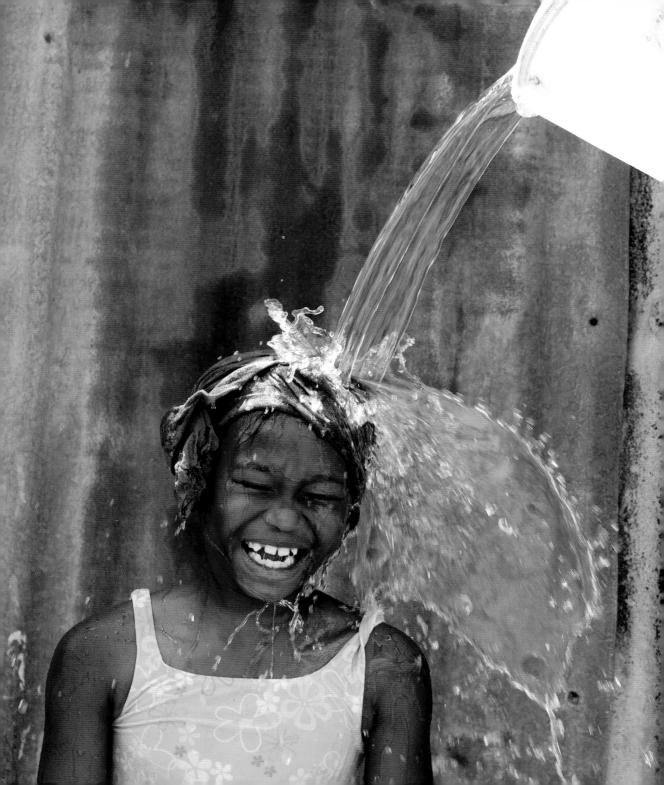

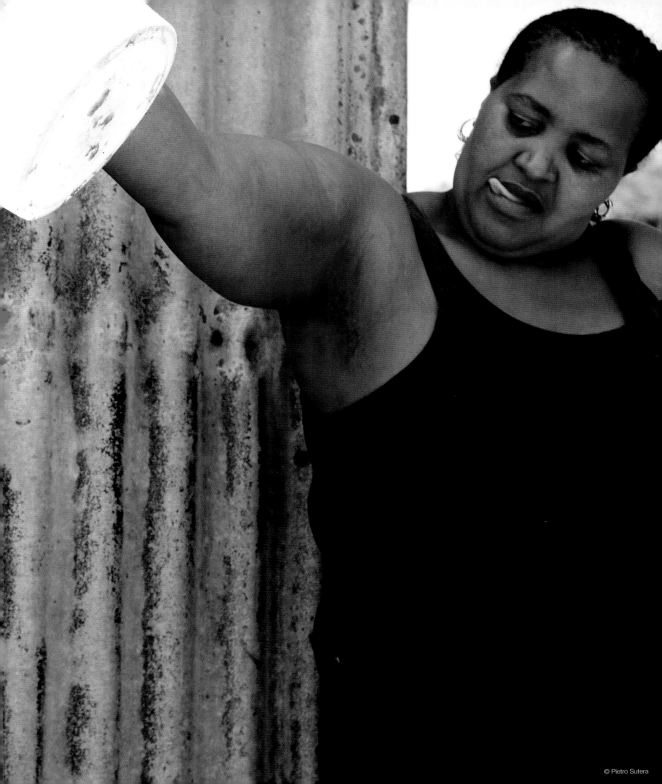

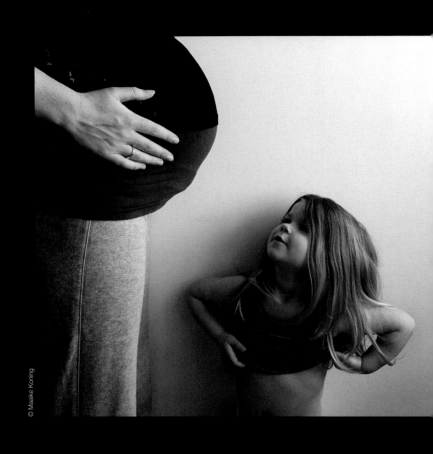

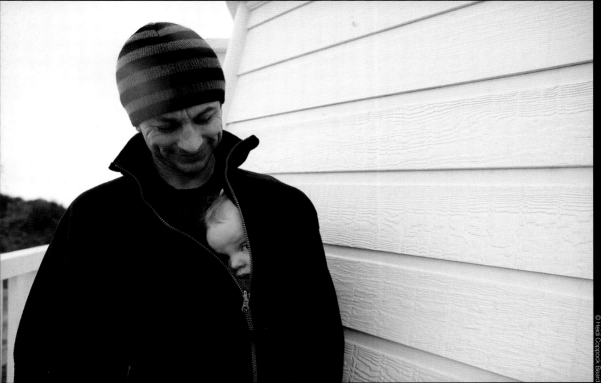

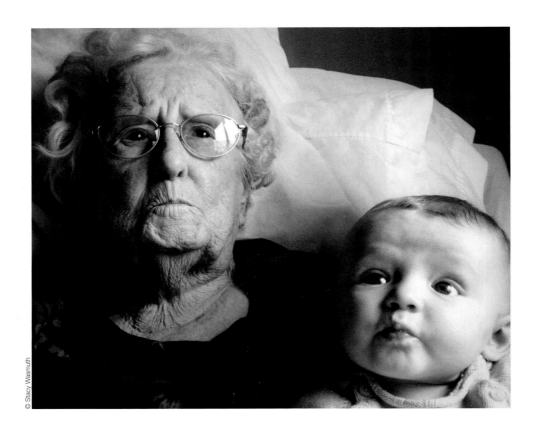

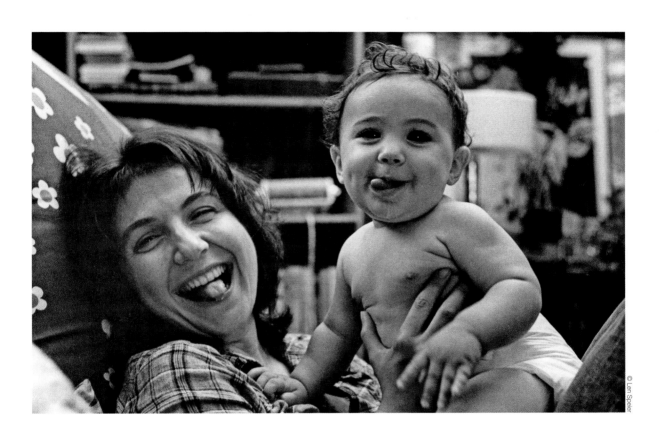

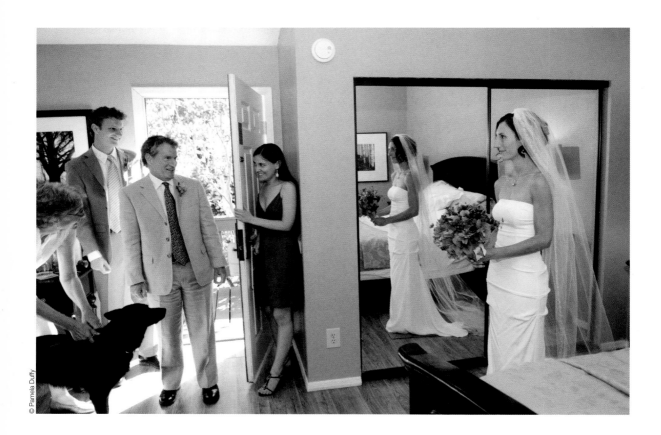

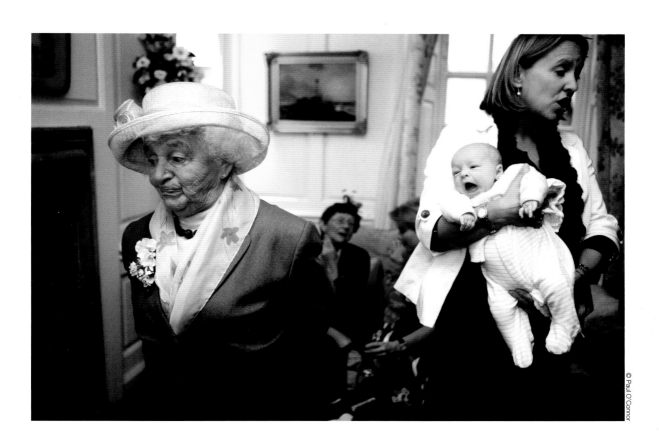

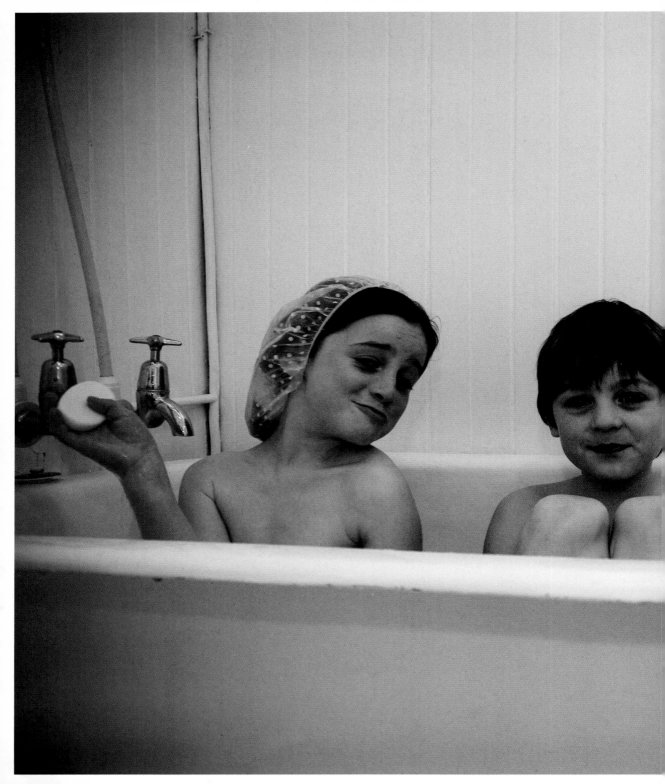

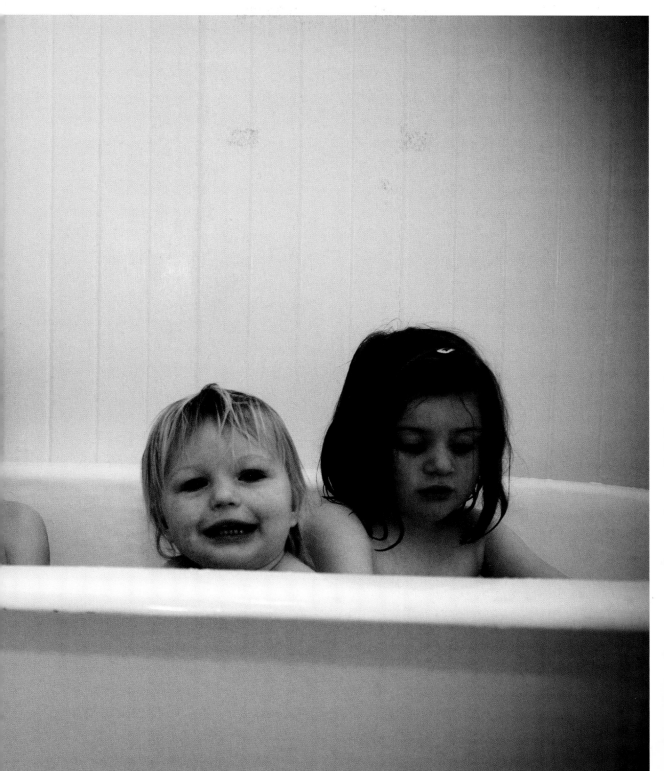

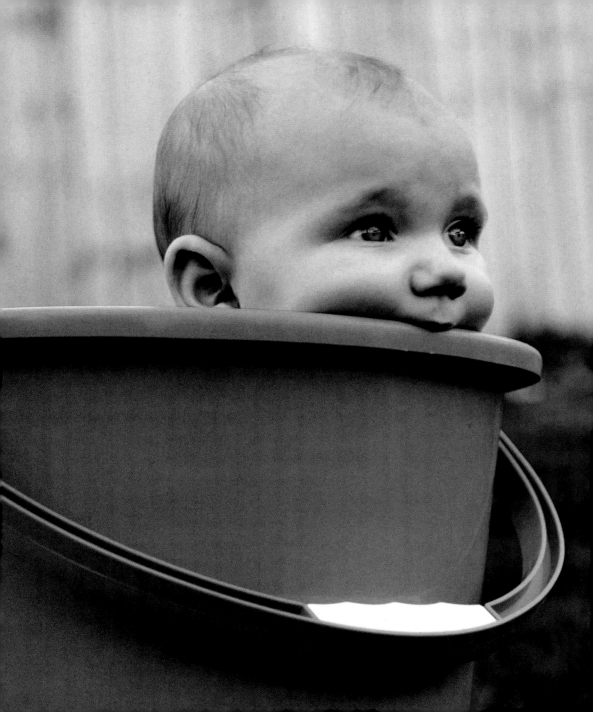

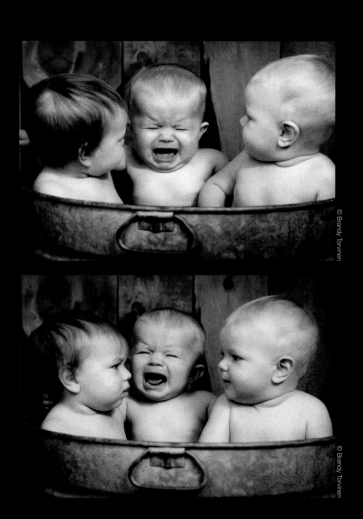

Love

is the only

passion

which includes in its

dreams

the *happiness*

of someone else.

Jean-Baptiste Alphonse Karr

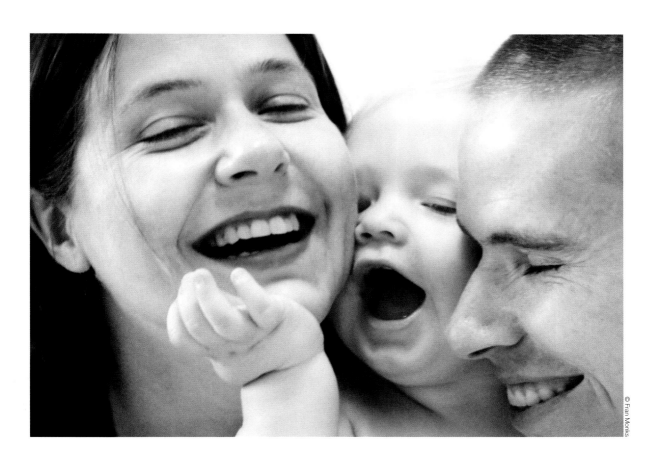

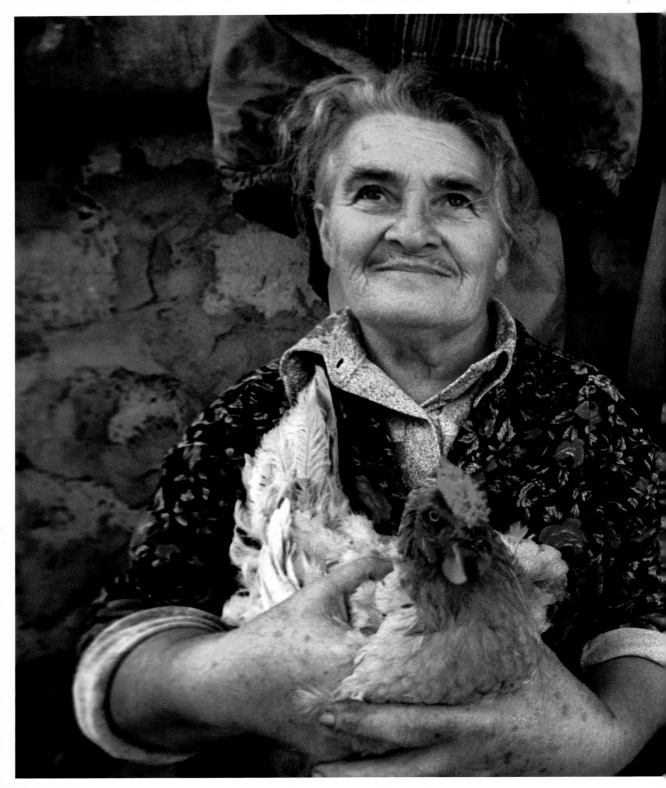

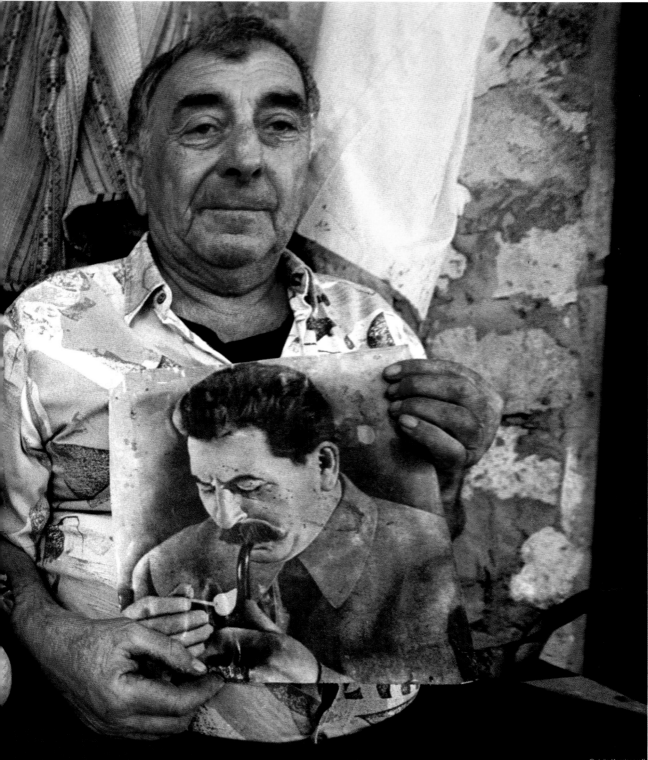

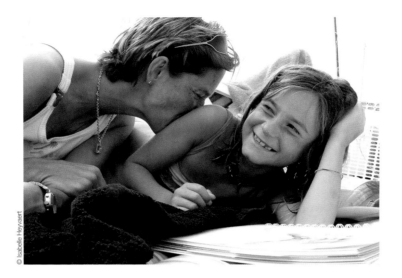

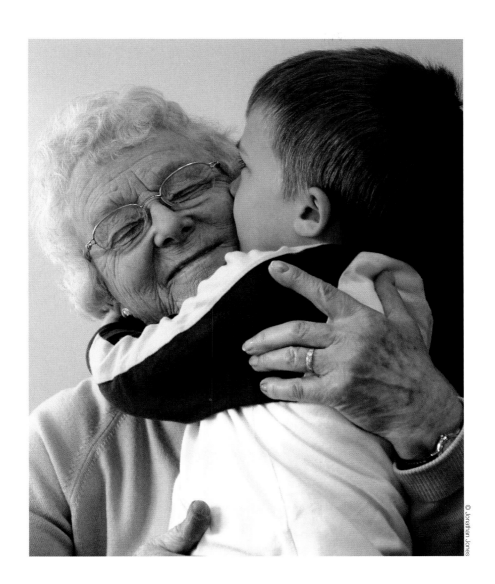

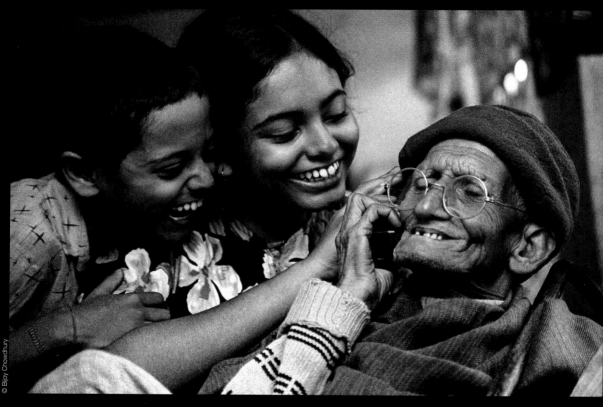

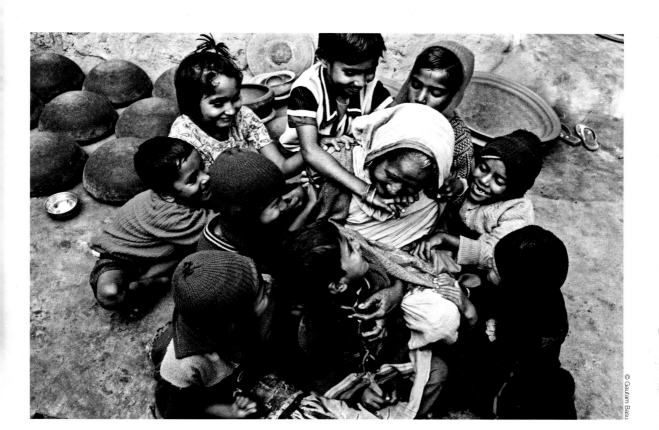

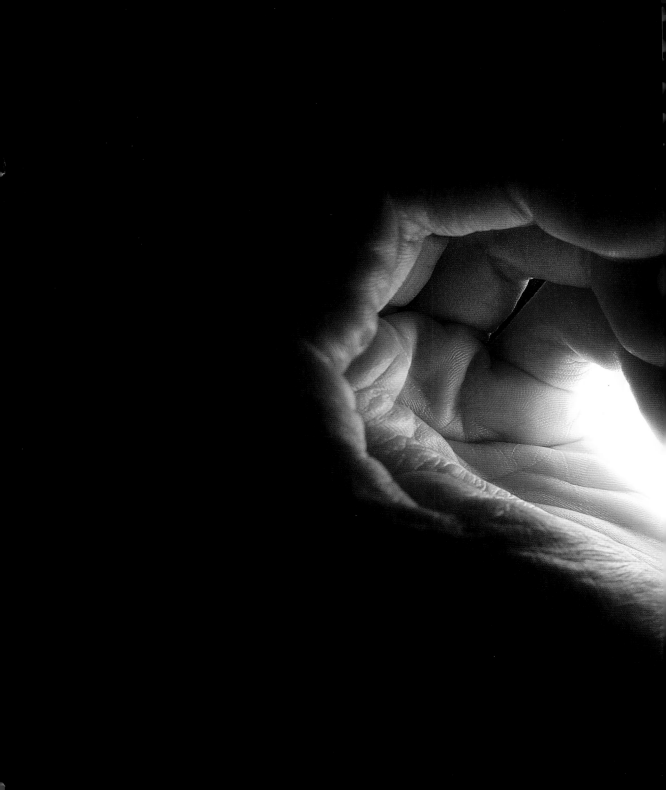

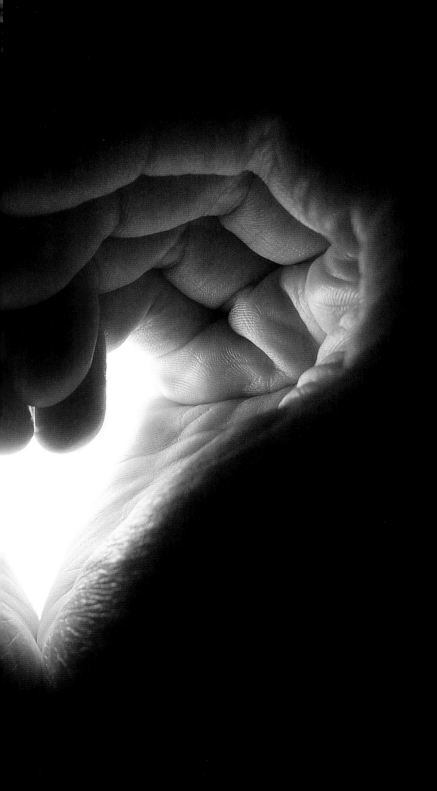

Love
is *friendship*
set to
music.

E. Joseph Cossman

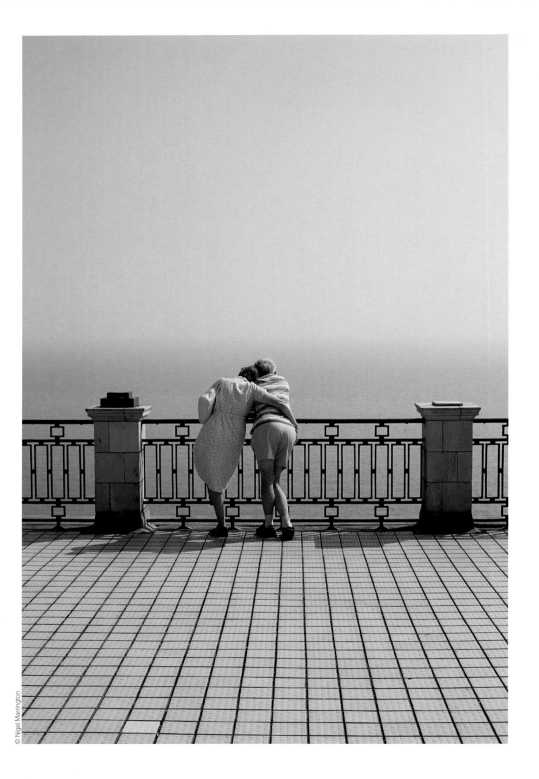

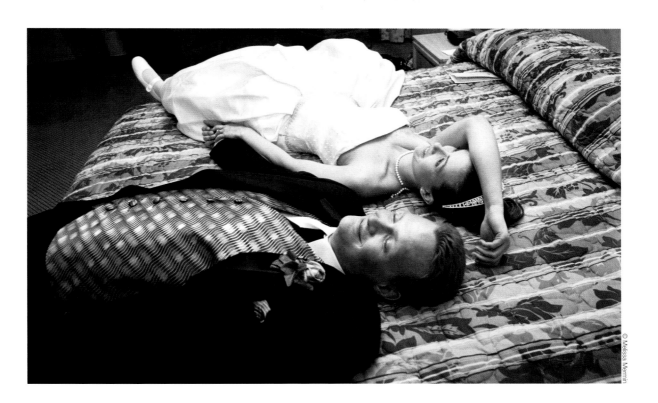

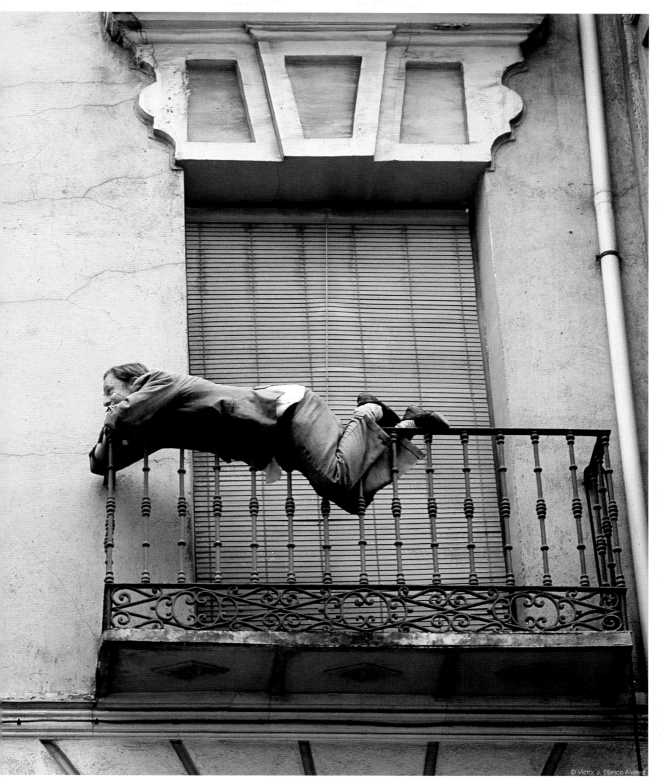

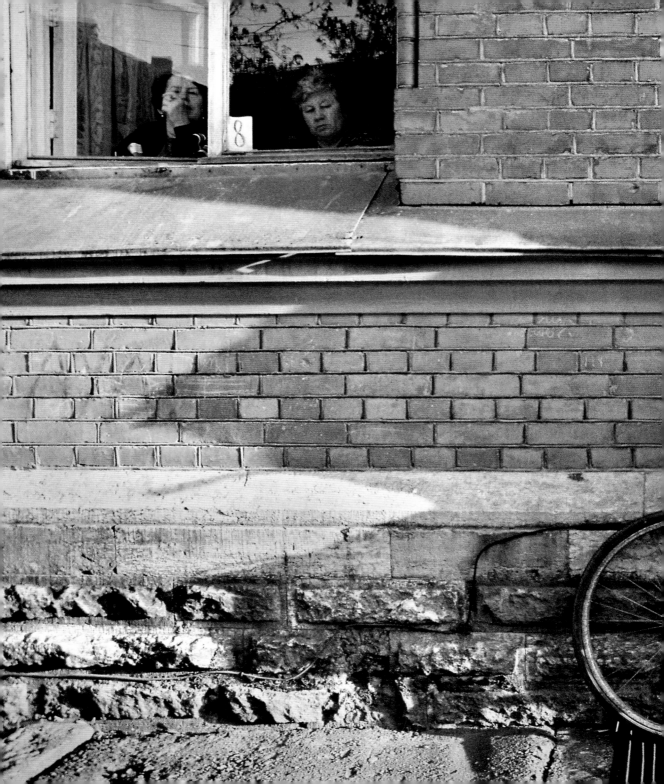

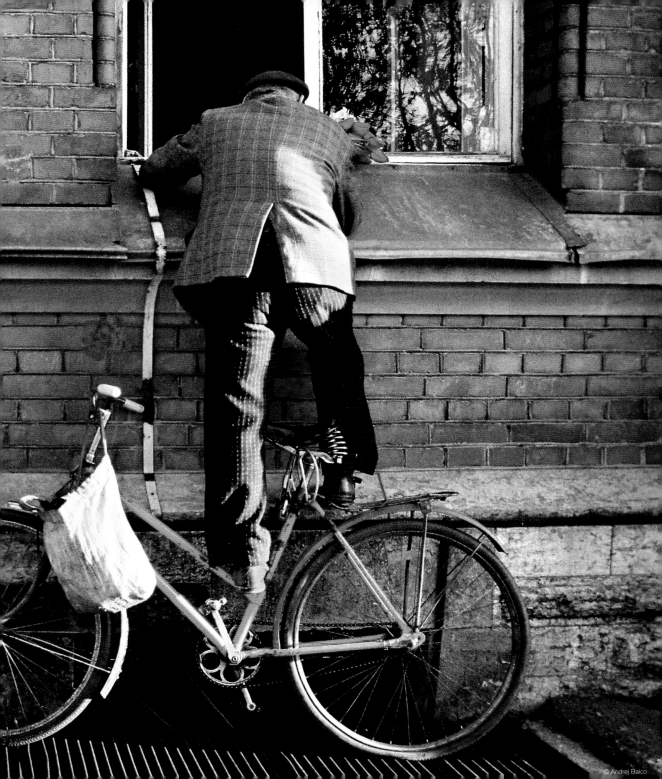

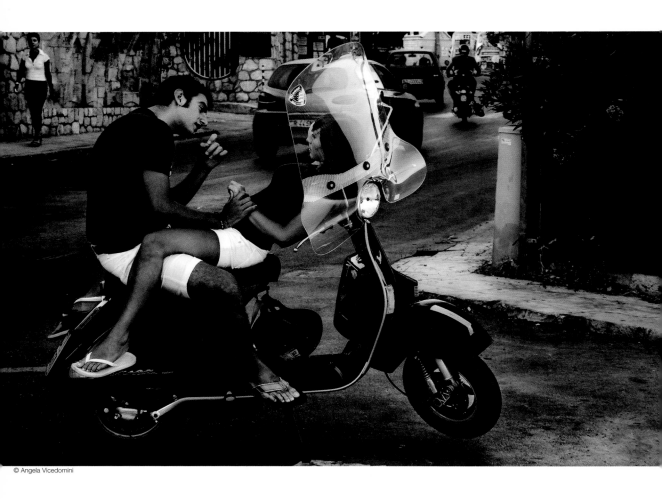

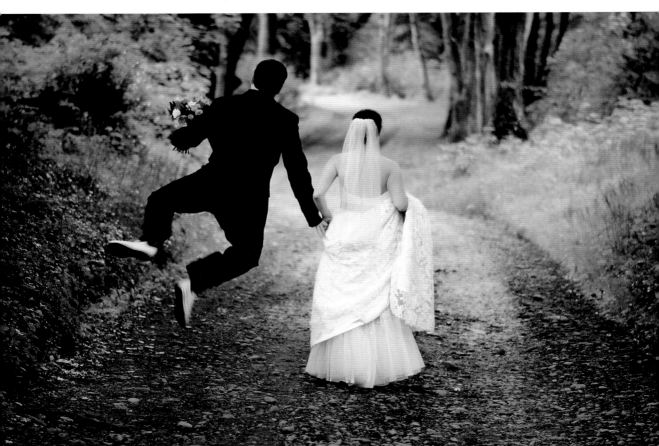

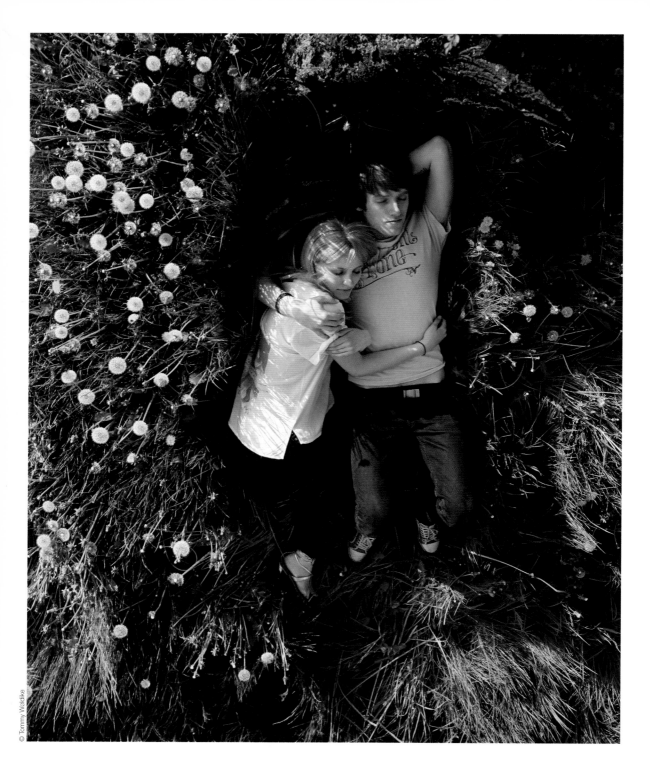

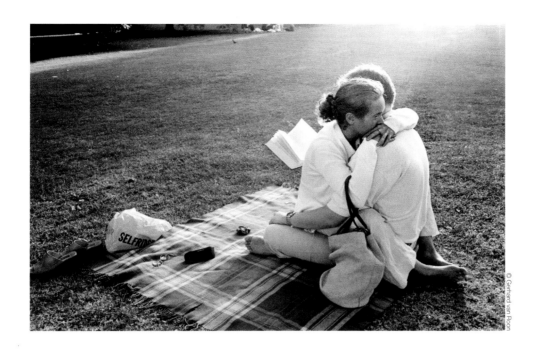

© Gerhard van Room

Being with you
is like walking
on a very
clear
morning.

E.B. White

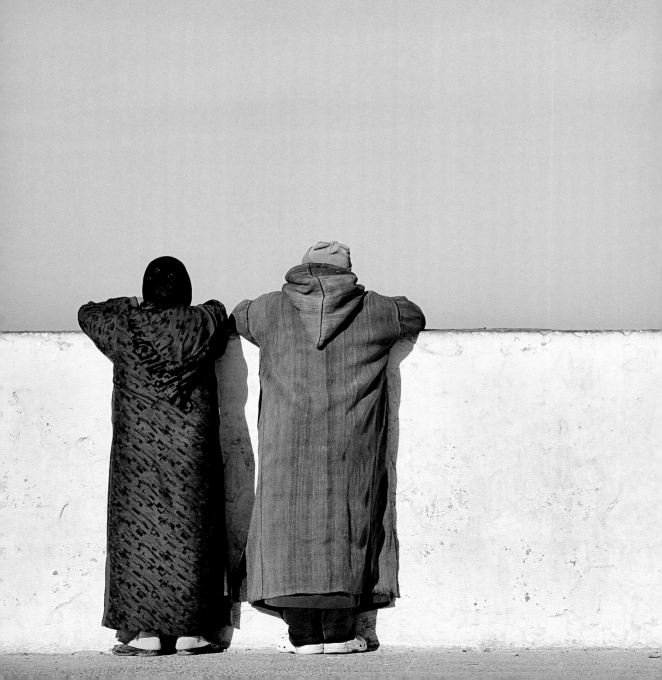

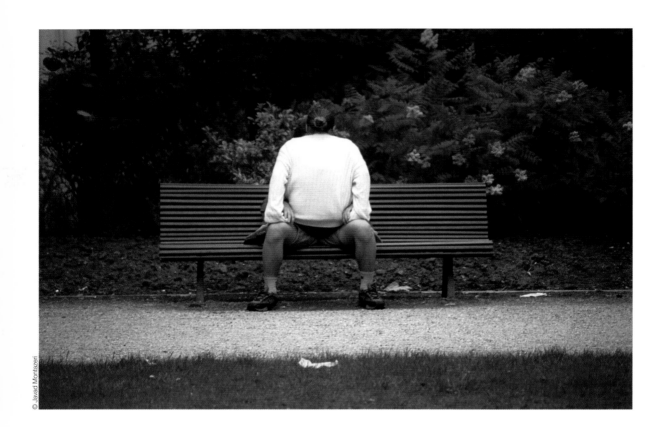

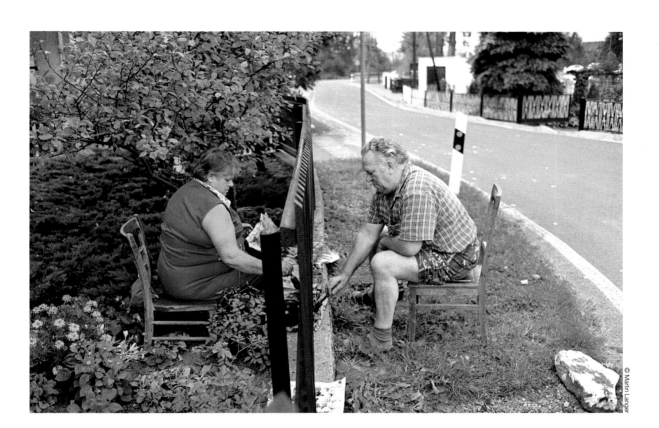

© Joyce Smith

The longer
I live
the more
beautiful
life
becomes.

Frank Lloyd Wright

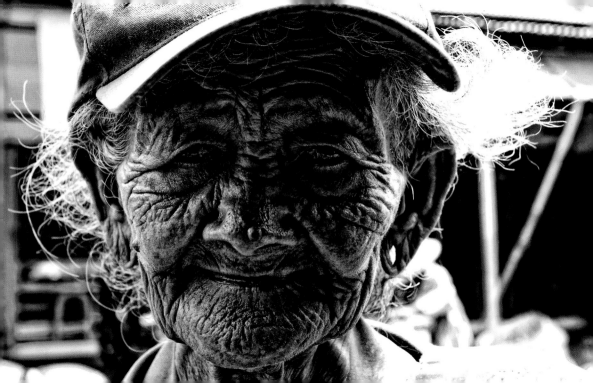

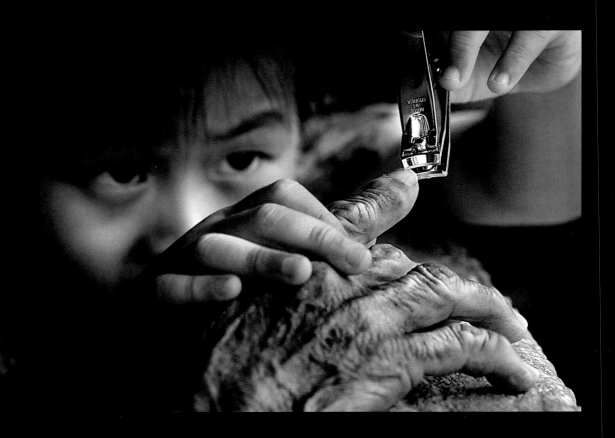

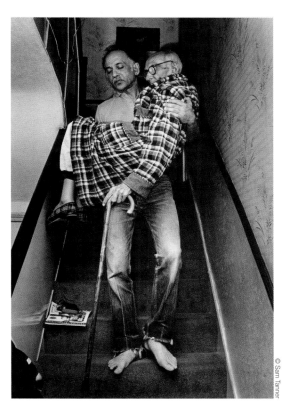

© Sam Tanner

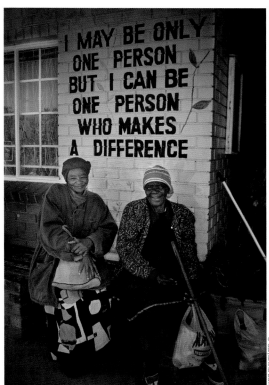

I MAY BE ONLY
ONE PERSON
BUT I CAN BE
ONE PERSON
WHO MAKES
A DIFFERENCE

© Samantha Davis

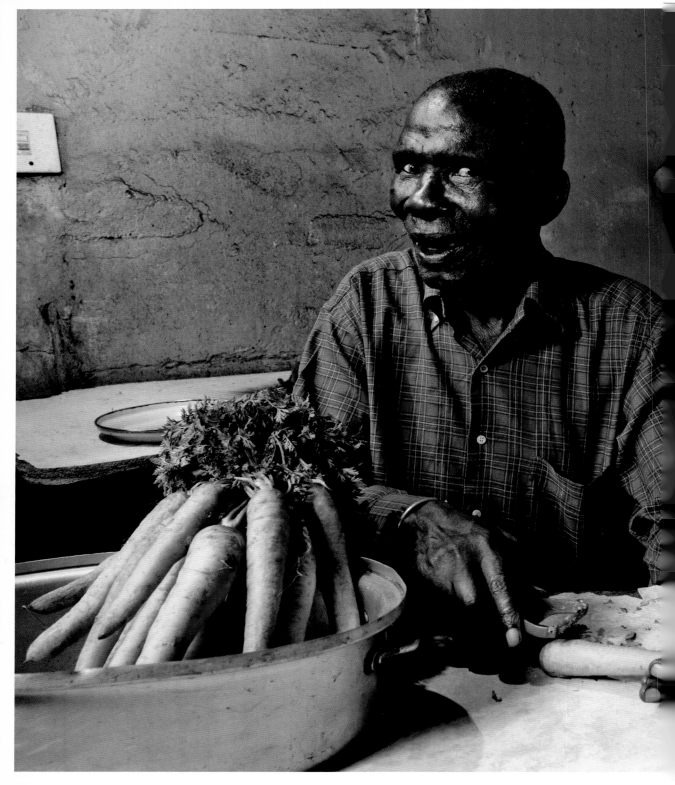

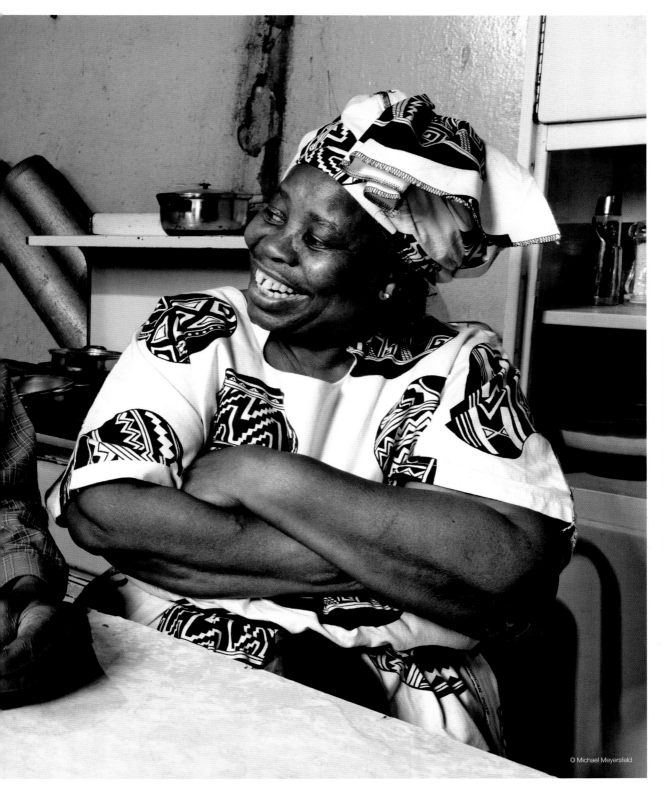

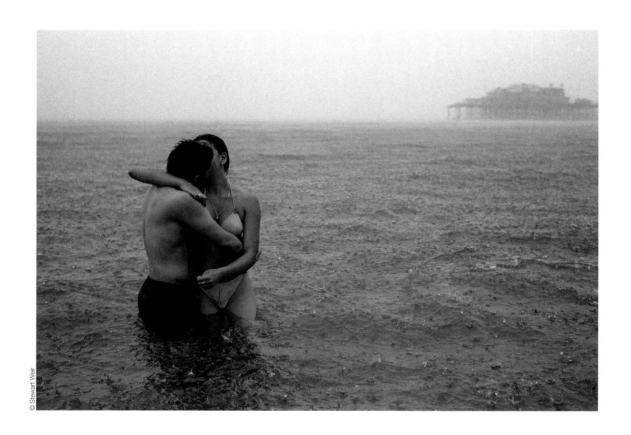

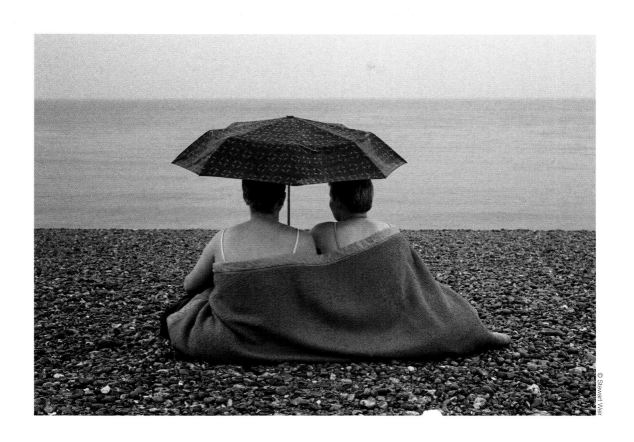

With mirth
and laughter
let old
wrinkles
come.

William Shakespeare

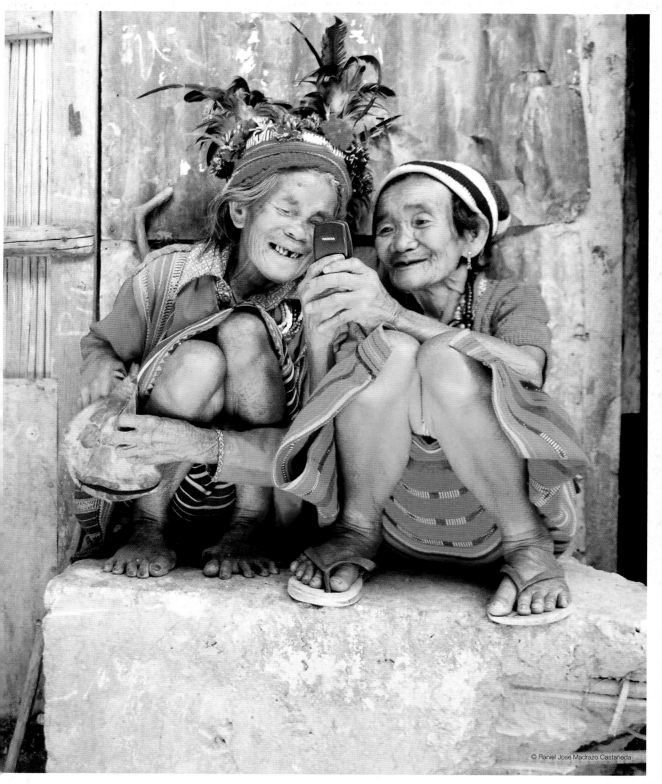

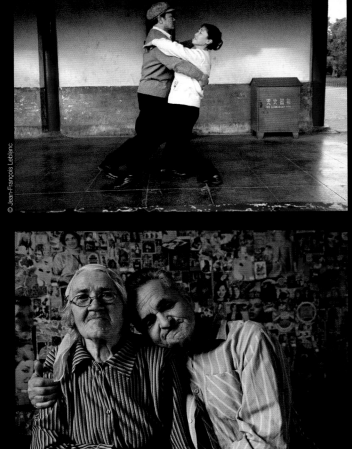

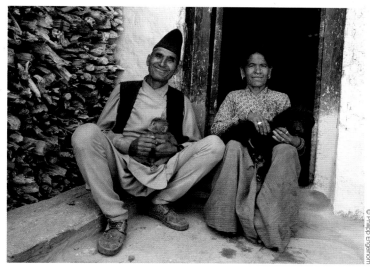

© Philipp Engelhorn

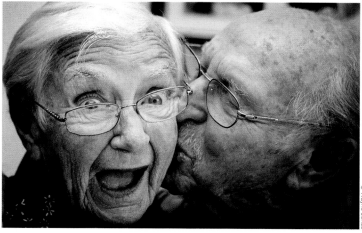

© Wayne Jones

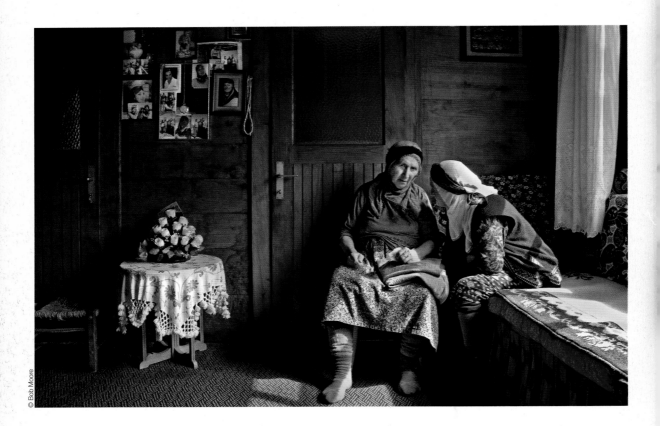

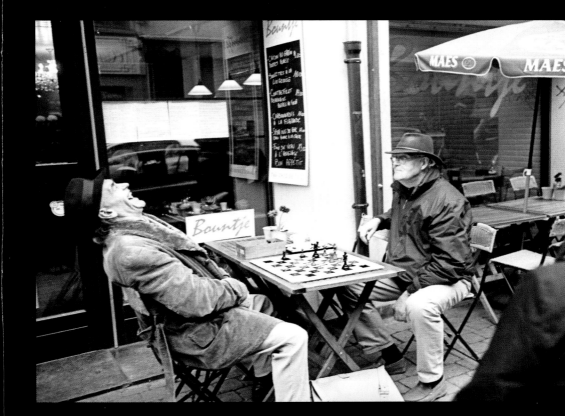

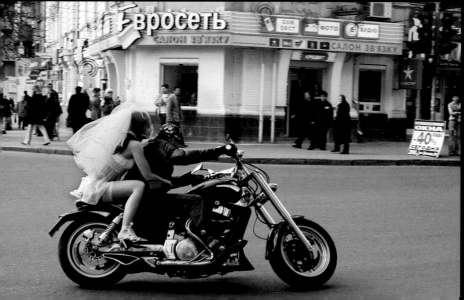

Fun *is* good.

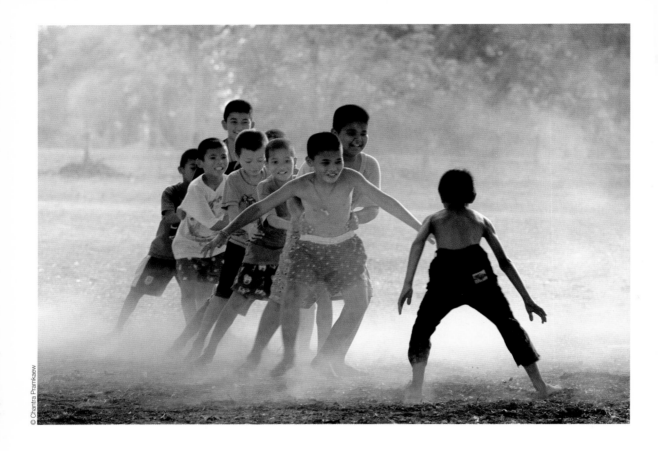

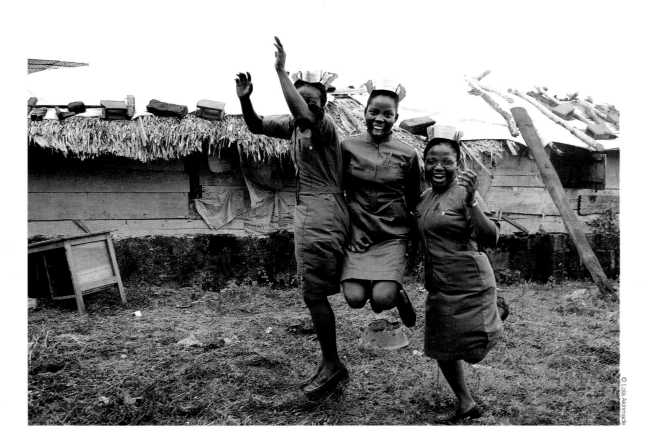

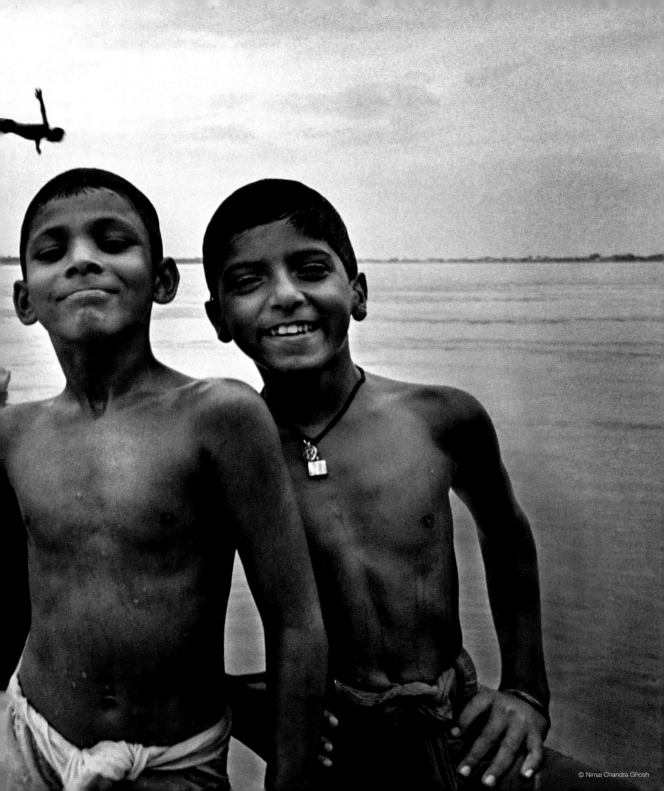

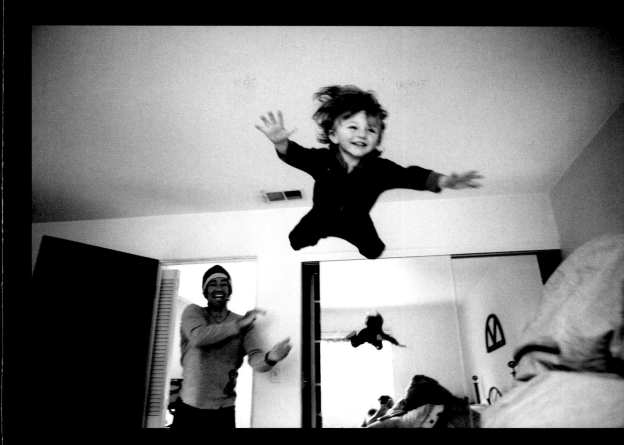

The world is
extremely
interesting to a
joyful
soul.

Alexandra Stoddard

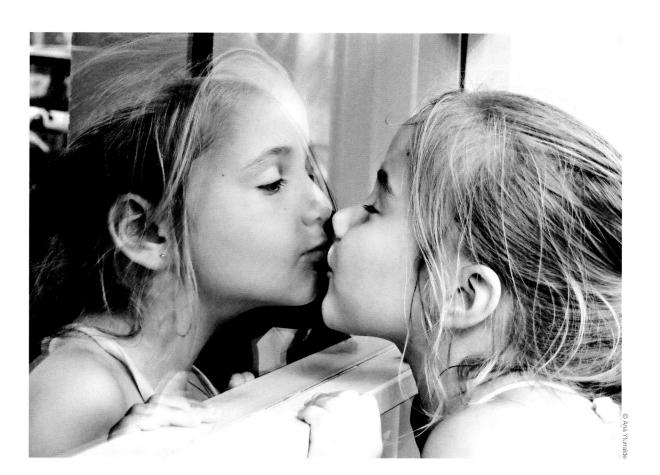

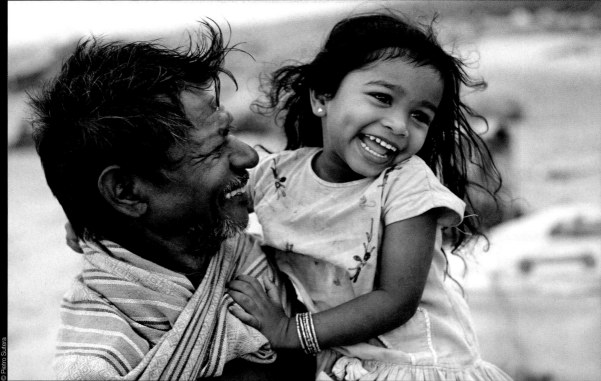

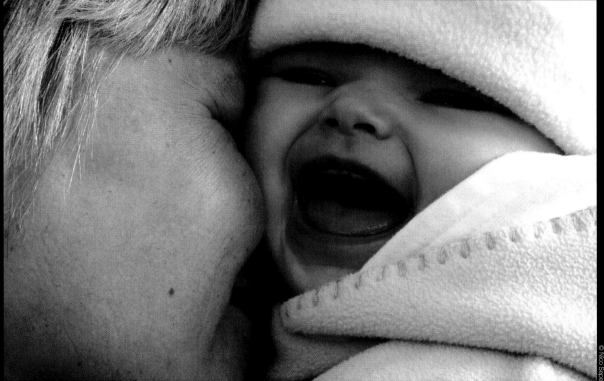
© Nico Sepe

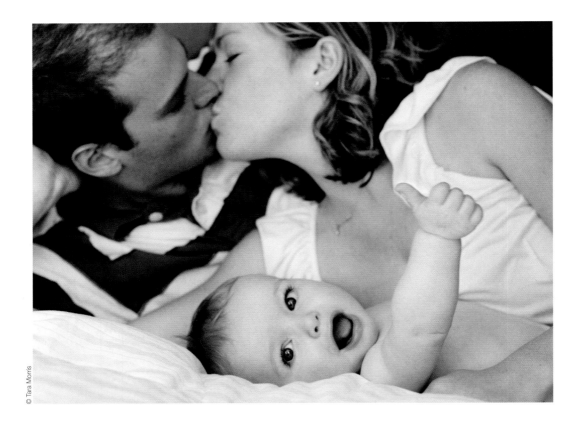

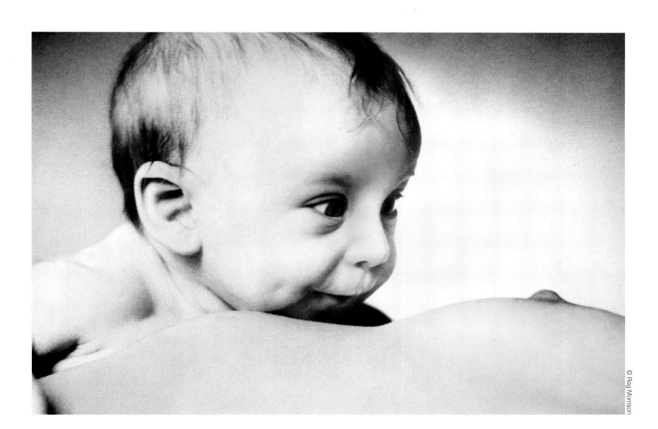

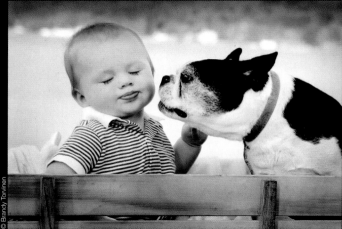

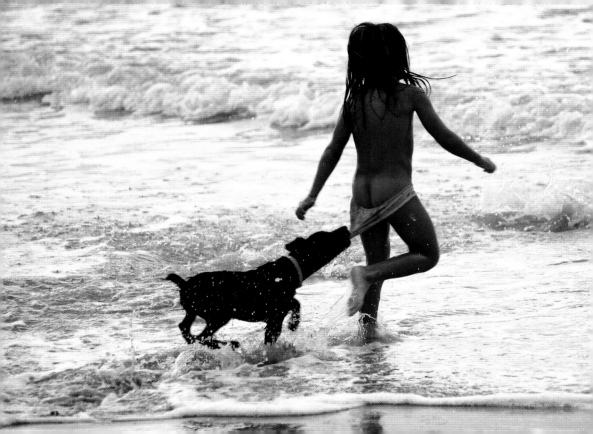

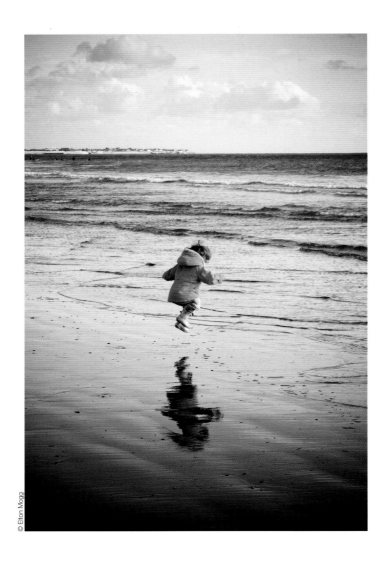

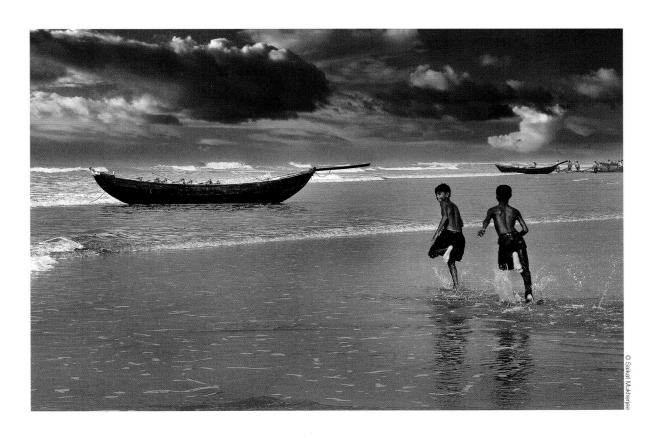

Laugh
as much as you
breathe
and love
as long as you
live.

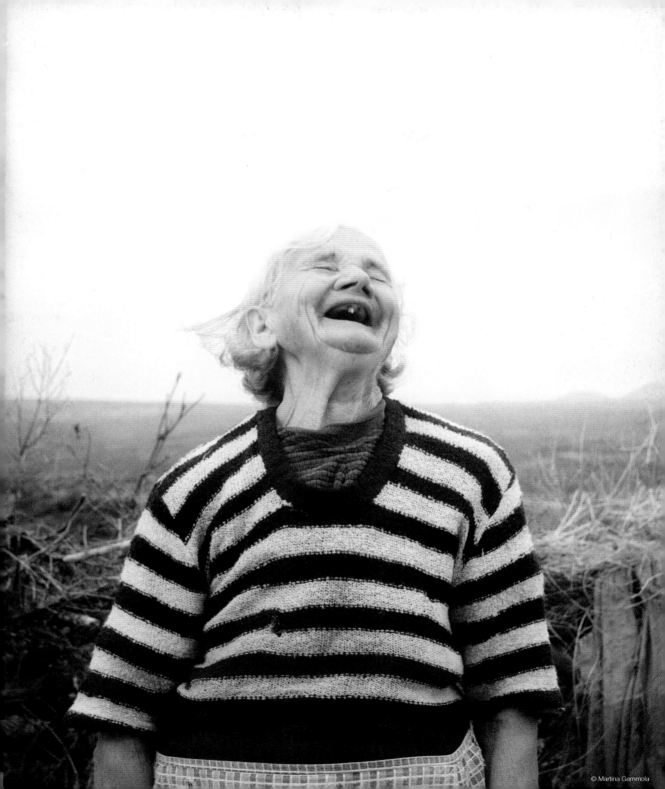

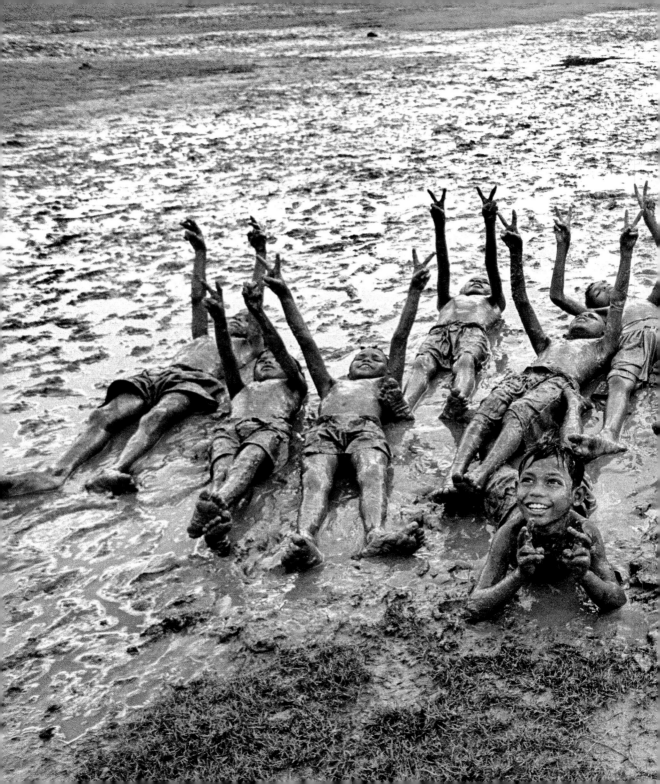

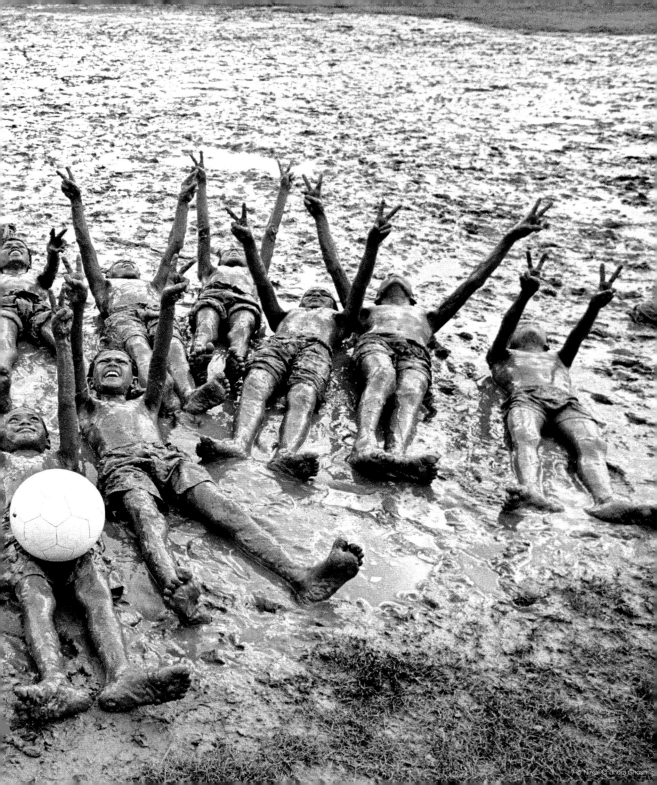

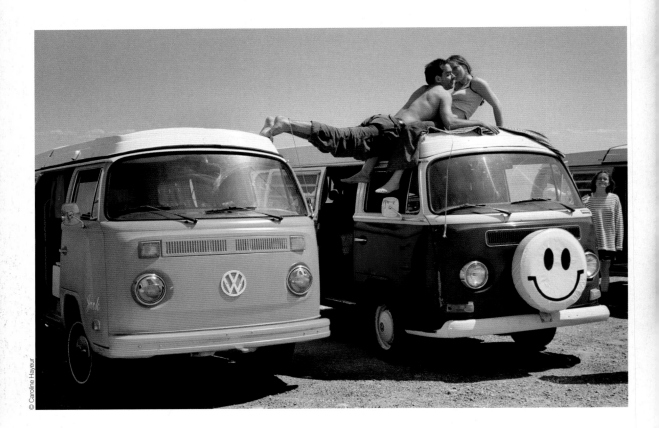

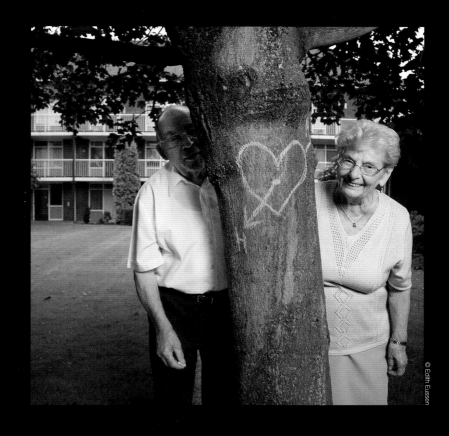

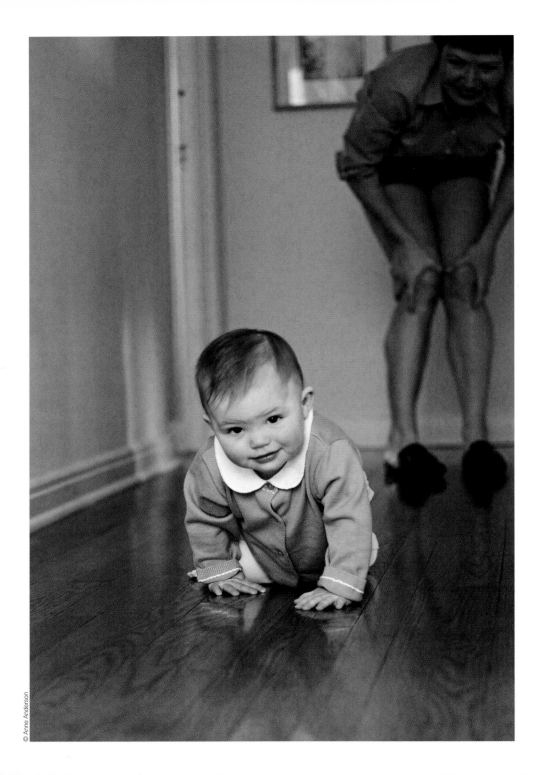

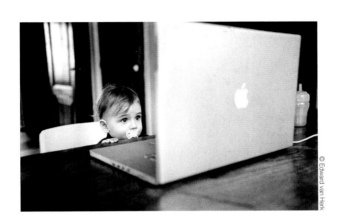

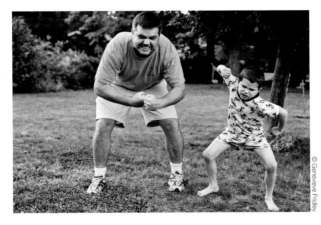

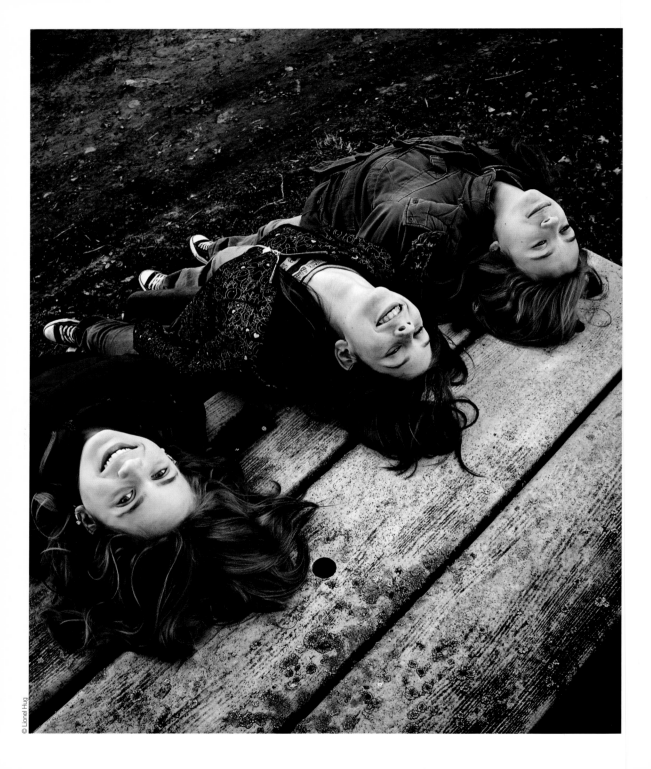

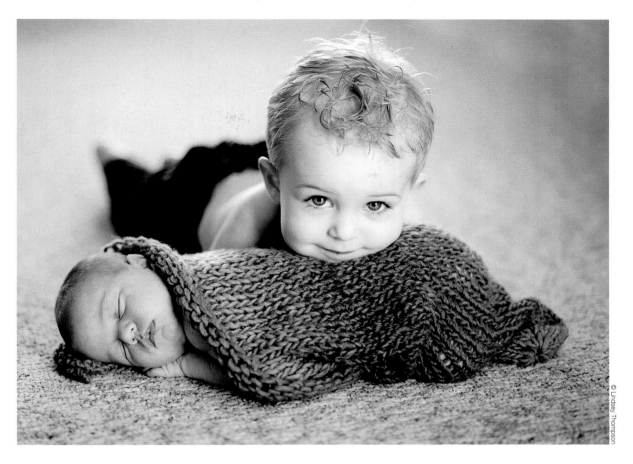

It is almost
impossible to
smile
on the outside
without feeling
better
on the inside.

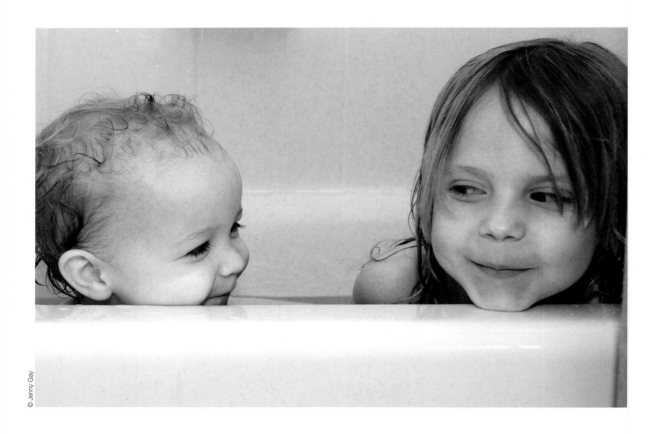

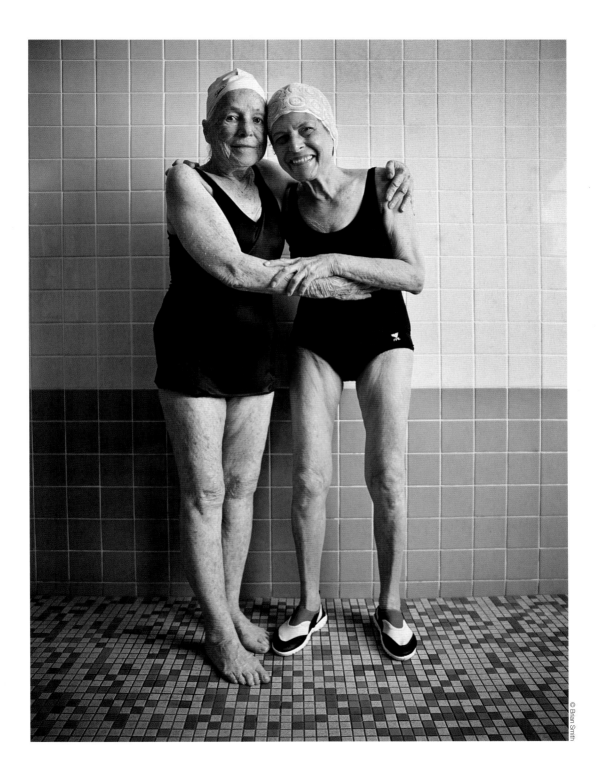

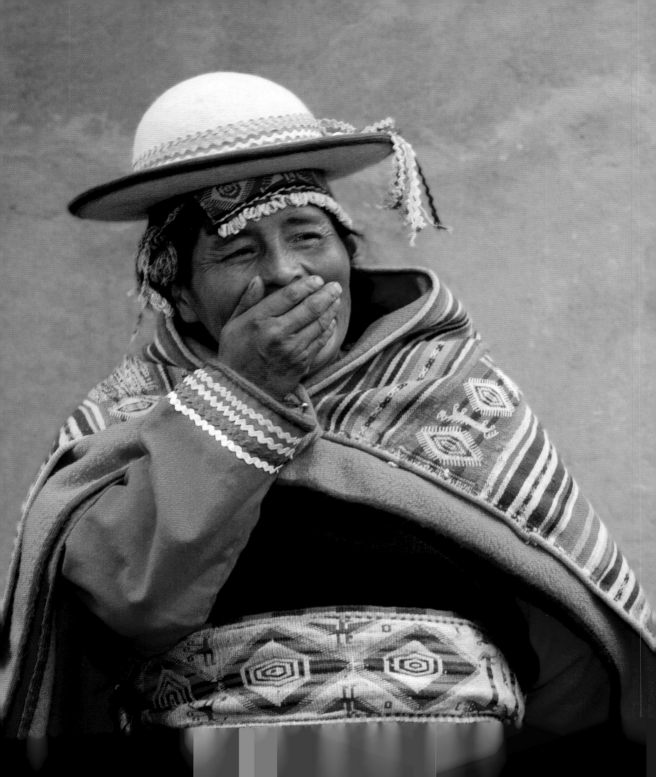

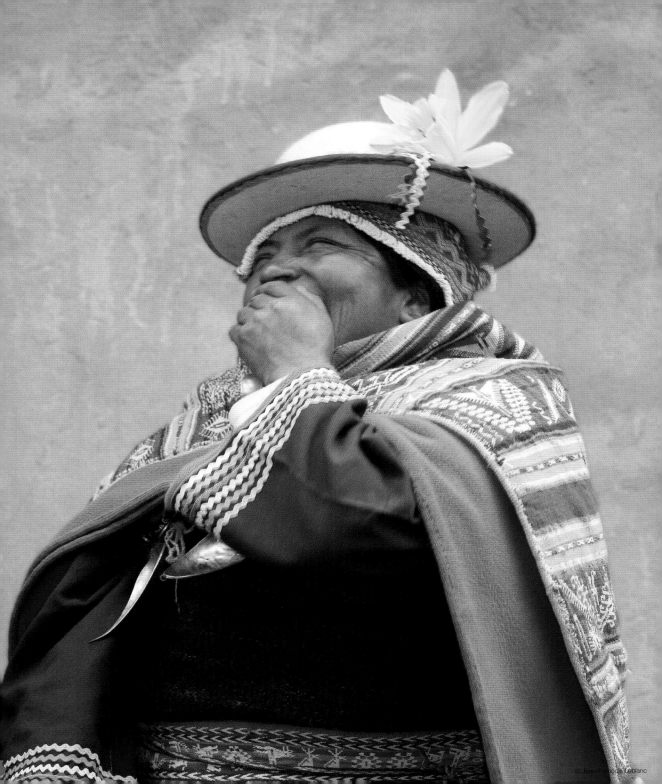

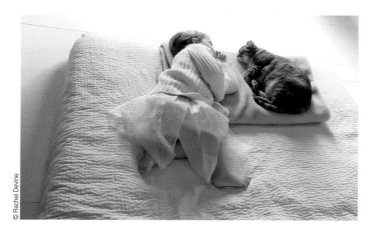

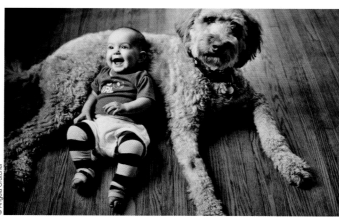

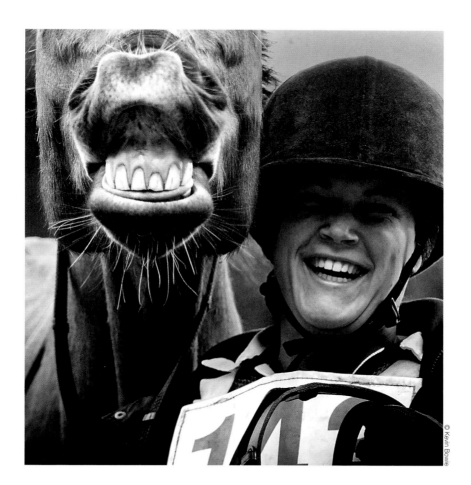

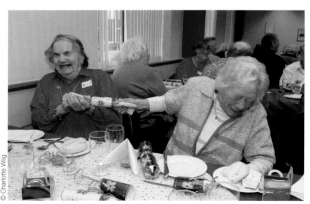

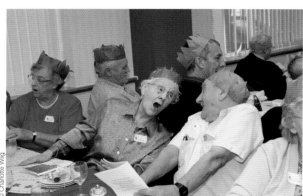

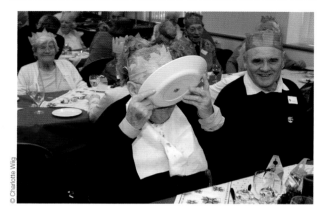

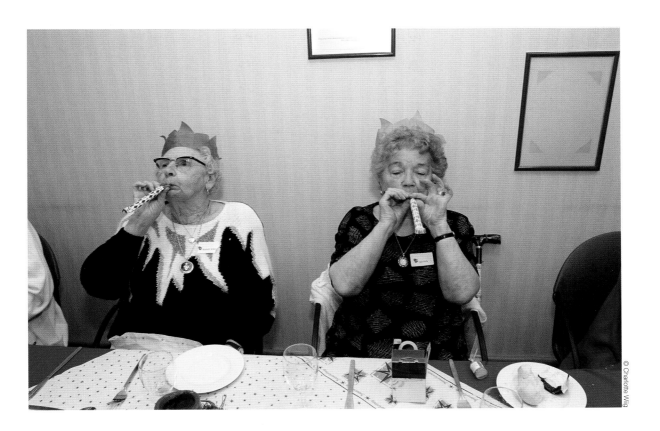

A *friend* hears
the song
in my heart and
sings it
to me
when my memory fails.

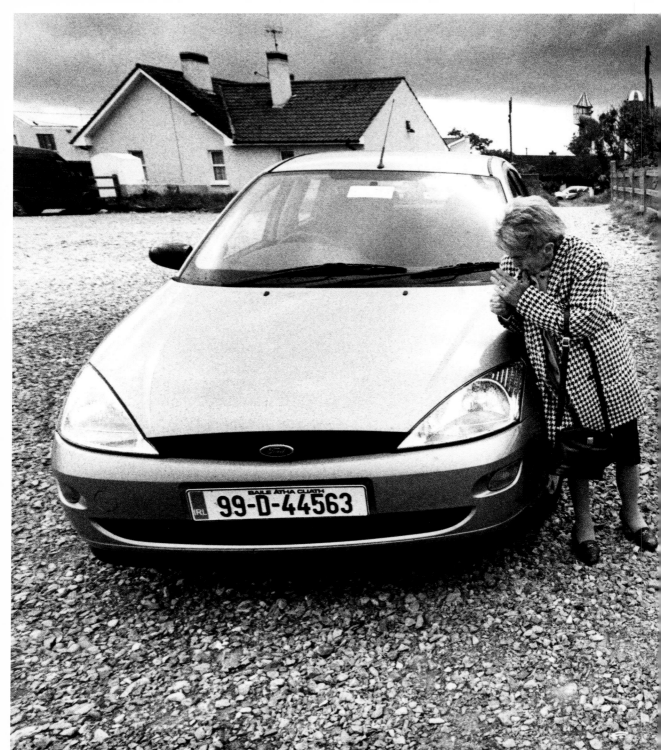

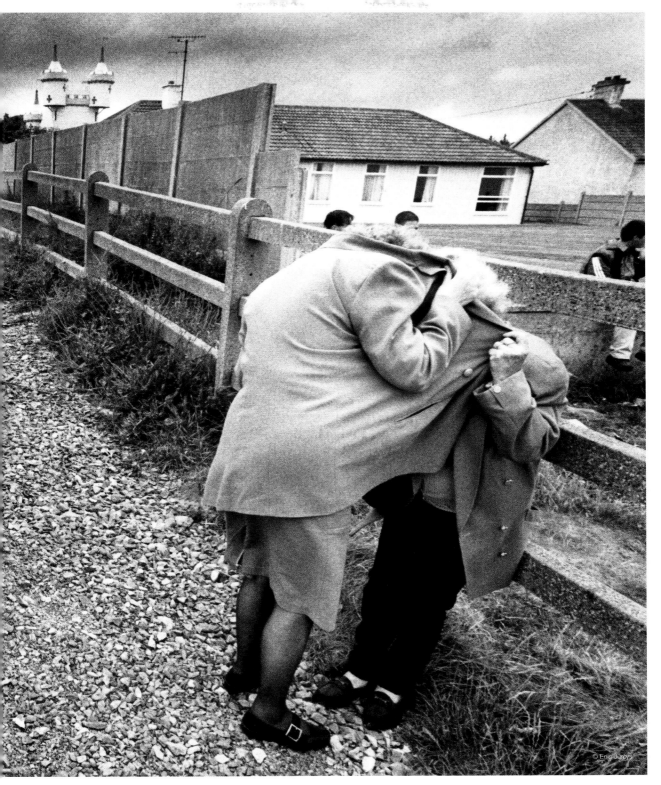

Friends...
they cherish
one another's
hopes.
They are kind to
one another's
dreams.

Henry David Thoreau

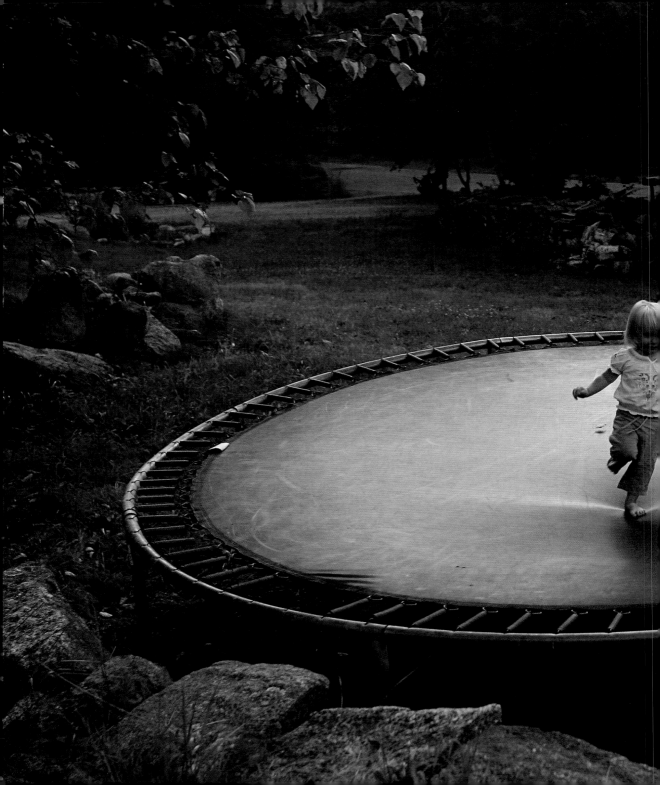

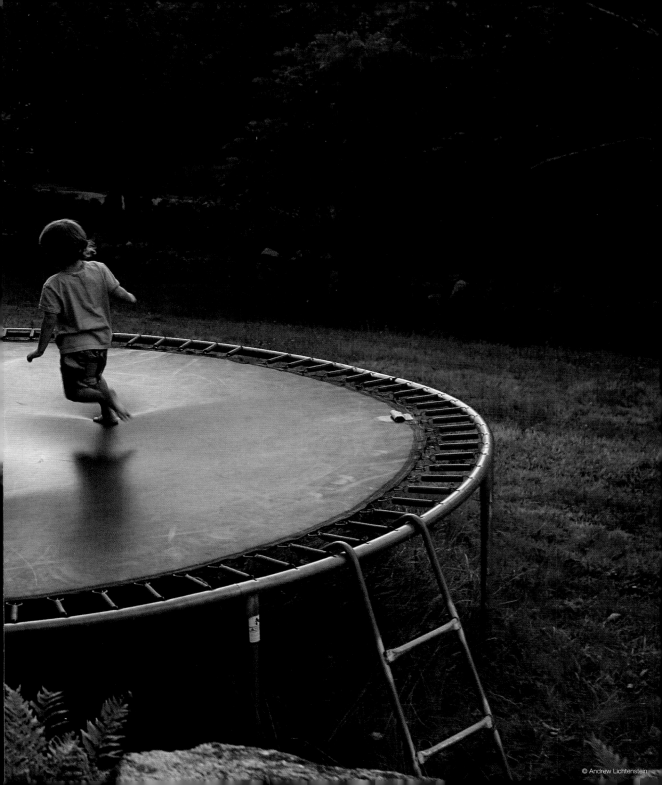

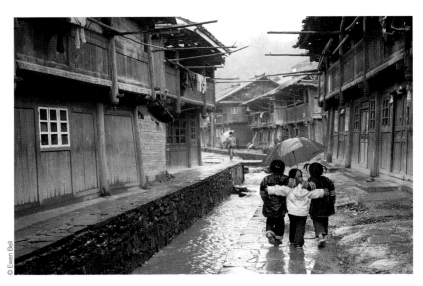

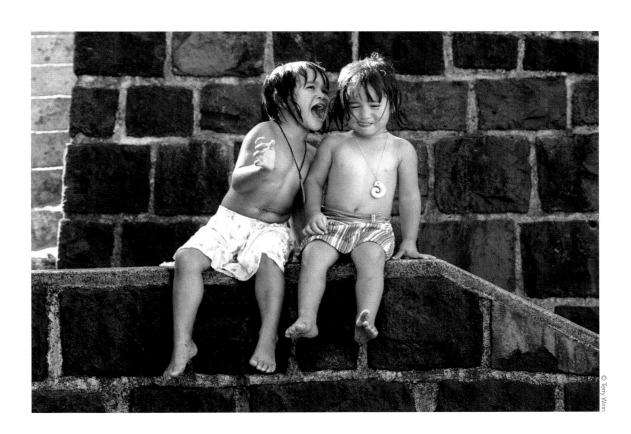

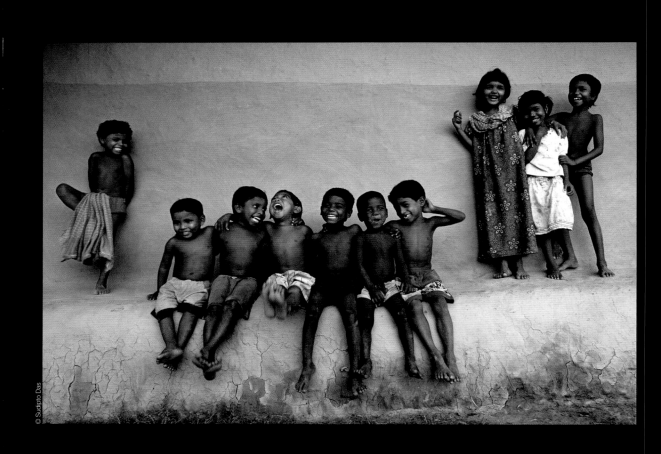

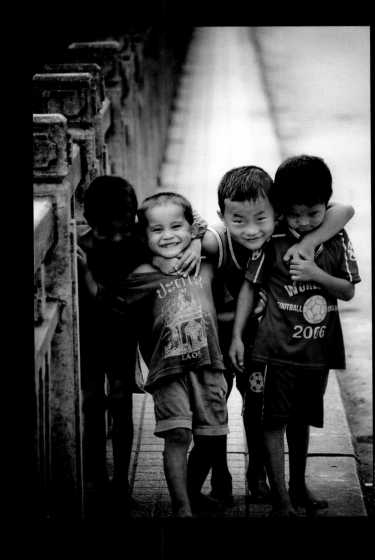

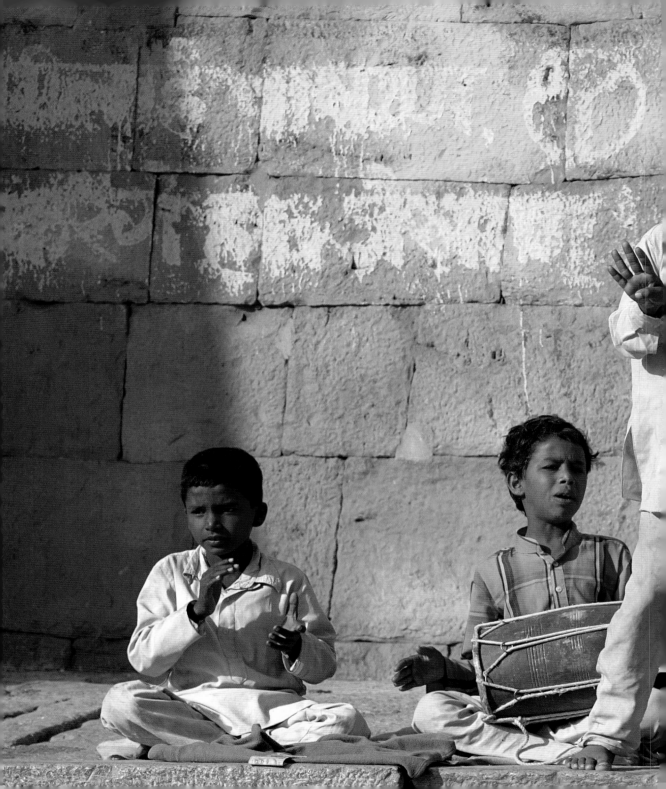

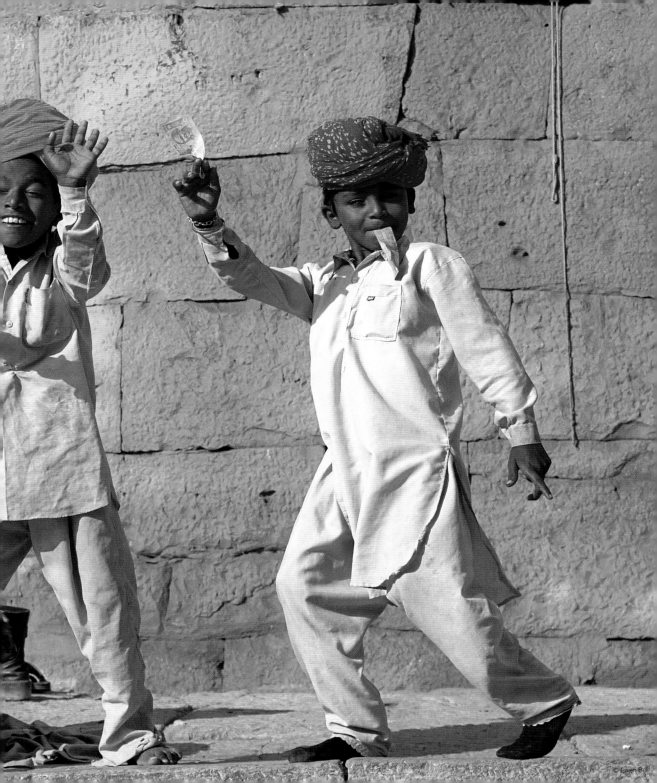

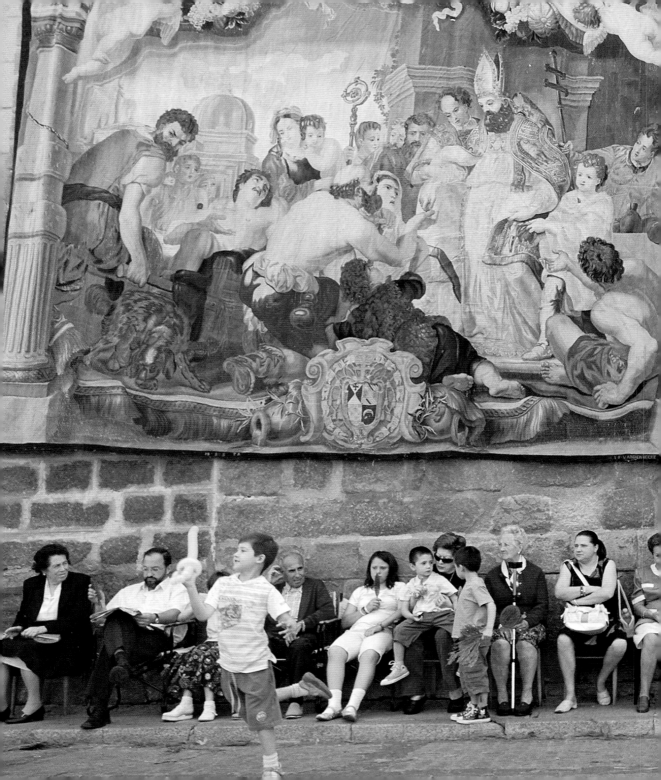

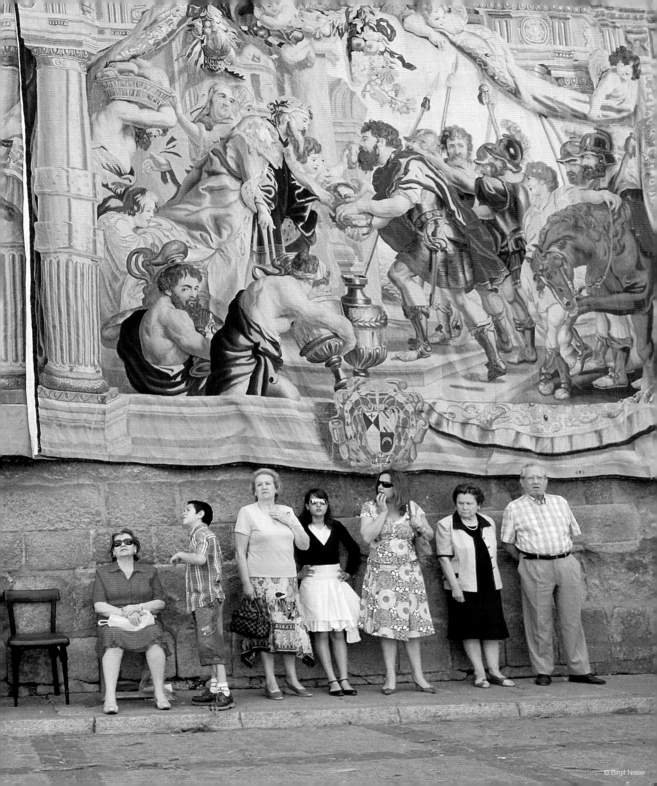

PHOTOGRAPHERS' BIOGRAPHIES

PHOTO CAPTIONS

Jaka Adamič
SLOVENIA

A self-taught photographer, Jaka Adamič is a photojournalist whose work appears regularly in publications throughout Slovenia. He is a staff photographer on the national newspaper *Dnevik*.

Wahid Adnan
BANGLADESH

Wahid Adnan studied law at Chittagong University in Bangladesh, but chose to become a photographer rather than a lawyer. He is now studying photojournalism in Dhaka, Bangladesh, and also working with DrikNEWS, an international news photo agency.

Lola Akinmade
USA

Lola Akinmade's photography and travel writing have appeared in various online and print publications. She also volunteers as a photojournalist for non-profit organizations.

Anne Anderson
USA

Anne Anderson studied design and photography at Purdue University and now runs a studio, fotoWonder, where she takes both commercial photographs and portraits. She lives in Indianapolis, Indiana, USA.

Fabiano Avancini
ITALY

Inspired by his photographer father, Fabiano Avancini decided early on to make photography his career, too. Living and working in Vicenza, Italy, he now divides his professional time between fashion and advertising photography and what he calls "concerned photojournalism."

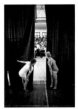

© Jaka Adamič

(p. 53) School girls from a dance group in Zuzemberk, Slovenia, wait to go on stage to perform for their honored guest, the late Slovenian president Janez Drnovšek.

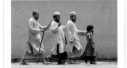

© Wahid Adnan

(pp. 42–43) A little girl leads her blind father and his two blind companions as they beg in a street in Chittagong, Bangladesh.

www.wahidadnan.com

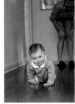

© Lola Akinmade

(pp. 140–141) Three student nurses let off steam after a long seminar in the village of Awoyaya, Lagos, Nigeria.

www.lolaakinmade.com

© Anne Anderson

(p. 162) One-year-old Grace shows off her crawling prowess to her mother, Jamie, in their home in Indianapolis, Indiana, USA.

www.fotoWonder.com

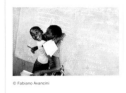

© Fabiano Avancini

(p. 22) After learning that depression was becoming increasingly widespread, the photographer wanted to portray simple acts of love, as in this image of children in Lwena, Angola.

www.labo.it

Marcel Bakker
NETHERLANDS

Marcel Bakker studied psychology and photography in the USA and medicine and cultural anthropology in the Netherlands. He now works as a freelance photographer for a variety of magazines and is affiliated with Dutch press agencies.

Andrej Balco
SLOVAKIA

After graduating from university with a degree in social work, Andrej Balco was invited to take part in a course for novice photojournalists, which inspired him to take up photography as a profession. His work has included commissions to produce photo essays about Slovakia and Brazil.

Gautam Basu
INDIA

Always an interested amateur, Gautam Basu took up photography more seriously when he retired as deputy manager of the State Bank of India two years ago. Since then he has won a government award and taken part in a number of exhibitions.

Yves Beaulieu
CANADA

Yves Beaulieu was born in Quebec, Canada, and took his first photograph at the age of seventeen. Since then he has undertaken various commercial assignments, which usually reflect his humorous vision of the world.

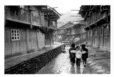

Ewen Bell
AUSTRALIA

Melbourne-based travel photographer and journalist Ewen Bell has won two awards from the Australian Society of Travel Writers: Travel Photographer of the Year 2007 and Best Australian Image 2008.

© Marcel Bakker

(p. 52) Two young friends in Haarlem, Netherlands, hide from the photographer.

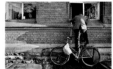

© Andrej Balco

(pp. 112–113) An elderly man in Narva, Estonia, visits his wife in hospital via the window while other patients look out to the street.

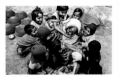

© Gautam Basu

(p. 103) In the village of Narsingpur in West Bengal, India, Sarojini, who comes from a family of potters, tells her grandchildren stories of her childhood.

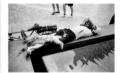

© Yves Beaulieu

(pp. 48–49) Two friends are captured in a street snapshot outside the Louvre in Paris, France.

www.beaulieuphoto.com

© Ewen Bell

(p. 180, above) Children walk home from school in Yin Tan, a village in Guizhou Province, China.

www.ewenbell.com

Víctor J. Blanco Álvarez
SPAIN

Born in the Spanish city of Valladolid, Víctor J. Blanco Álvarez was interested in photography as a child, but did not become deeply involved in it until he bought his first camera. Now it is his passion.

Kevin Bowie
NEW ZEALAND

People, landscape, and wedding photography are the passions of New Zealand photographer Kevin Bowie.

Raniel Jose Madrazo Castañeda
PHILIPPINES

Raniel Jose Madrazo Castañeda is a freelance photographer who uses his camera to share his passions for travel, the landscape, macro and portrait photography.

Nimai Chandra Ghosh
INDIA

Nimai Chandra Ghosh graduated from Calcutta University and took up photography in 1984. He has won numerous international awards for his work.

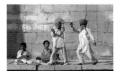

© Ewen Bell

(pp. 184–185) In the desert city of Jaisalmer in Rajasthan, India, children entertain tourists with dancing, drums, and songs.

www.ewenbell.com

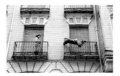

© Víctor J. Blanco Álvarez

(pp. 110–111) Not all the action is on the street during the street-theatre fair held every year in Valladolid, Spain.

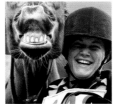

© Kevin Bowie

(p. 171) The photographer's daughter, Leigh, smiles beside her horse, Beaver, at an equestrian event in Christchurch, New Zealand.

www.eunoiaphoto.co.nz

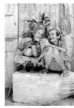

© Raniel Jose Madrazo Castañeda

(p. 133) Two friends from the Ifugao province in the Philippines view a mobile phone.

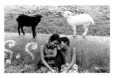

© Nimai Chandra Ghosh

(p. 30) A pair of boys and a pair of goats are captured on a street in Kolkata, West Bengal, India.

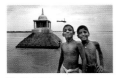

© Nimai Chandra Ghosh

(pp. 142–143) The Ganges, India, is a playground for boys who may one day see it as their livelihood.

Wen-Tzu Chang
USA

A freelance portrait and event photographer, Wen-Tzu Chang is based in Los Angeles, California, USA, but travels around the world for her work.

Bijoy Chowdhury
INDIA

Among several awards for his work, Bijoy Chowdhury lists a Fellowship in Photography from the Indian government and a Commonwealth Photography Award. He has taken part in solo and group exhibitions in the UK, India, France, Poland, Tokyo, and China.

Nancy Clendaniel
USA

Photojournalist Nancy Clendaniel is best known for her work as house photographer for the Beverly Theater in Beverly Hills, California, USA. She also specializes in travel and public-relations photography, and has worked as an archivist cataloging Beatles memorabilia.

Heidi Coppock Beard
NEW ZEALAND

Heidi Coppock Beard is a professional photographer from the UK who specializes in food and lifestyle photography. Her work appears in advertising campaigns and editorials worldwide and she is a regular contributor to Getty Images. She currently lives with her family on an island off the coast of New Zealand.

© Nimai Chandra Ghosh

(pp. 158–159) In Parganas, India, village children are triumphant at winning their football finals match.

© Wen-Tzu Chang

(p. 45) Richard and Betty share a tender moment at the wedding of their grandson, Roger, in Dana Point, California, USA.

www.wentzu.com

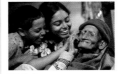

© Bijoy Chowdhury

(p. 102) A mobile phone connects a faraway son with his family in Siliguri, North Bengal, India.

www.bijoychowdhury.com

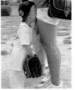

© Nancy Clendaniel

(p. 69) After missing a catch during a baseball game in Renton, Washington, USA, a little boy runs to his mother for comfort.

© Heidi Coppock Beard

(p. 87) At the top of a lighthouse on Awhitu Peninsula, New Zealand, Kirby shelters his daughter, Elizabeth, from the elements.

www.coppockbeard.com

Heather Crowder
USA

A native Annapolitan, Heather Crowder specializes in child and family photography.

Angela Crutcher
USA

Working in Tennessee, USA, Angela Crutcher specializes in photographing babies and children.

Sudipto Das
INDIA

A self-taught photographer, Sudipto Das has freelanced for magazines and photo agencies and now works as a senior photojournalist for the *Times of India*. He has won numerous national and international awards for his work.

Samantha Davis
SOUTH AFRICA

Samantha Davis grew up in Port Elizabeth, South Africa, and is studying photography at the Nelson Mandela Metropolitan University. Her work has already been included in three exhibitions.

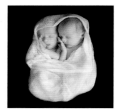

© Heather Crowder

(pp. 14–15) Two-week-old twin boys are photographed at their home in Annapolis, Maryland, USA.

www.heathercrowder.com

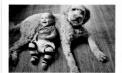

© Angela Crutcher

(p. 170, below) Eight-month-old Lily and Chewie take a rest after a game on their living-room floor.

www.angelacrutcherphotography.com

© Sudipto Das

(pp. 34–35) A small boy and his dog share a roadside doorstep for an afternoon nap in Kolkata, West Bengal, India.

www.viiphoto.ning.com/profile/sudiptodas

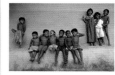

© Sudipto Das

(p. 182) Making the most of a day off school, children in a village in West Bengal, India, are entranced by a magic show during the festival of Lakshmi Puja.

www.viiphoto.ning.com/profile/sudiptodas

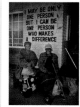

© Samantha Davis

(p. 127, right) Maive and Rynie wait in line for their meal at the care centre which provides food for more than 700 people each day in Missionvale, Port Elizabeth, South Africa.

www.samanthajanephotography.com

Rachel Devine
AUSTRALIA

An American, Rachel Devine now lives in Melbourne, Australia, where she specializes in photographing children.

Frank DiMeo
USA

Frank DiMeo realized he wanted to become a photographer at the age of fourteen. He now takes pictures of weddings and has had his work featured in many well known publications, including on the cover of *Time* magazine.

Armen Dolukhanyan
UKRAINE

Street and portrait photography are hobbies for Armen Dolukhanyan who lives in the Ukrainian city of Kharkov.

Pamela Duffy
USA

Pamela Duffy has had her work published in magazines and has held solo exhibitions in São Paulo and Rio de Janeiro, Brazil. Her photography often focuses on women.

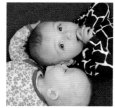

© Rachel Devine

(p. 63) The photographer's twins, five-month-old Clover and Kieran, play on the floor of their home in Melbourne, Australia.

www.racheldevine.com

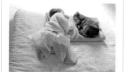

© Rachel Devine

(p. 170, above) Rachel Devine's elder daughter Gemma catnaps with Tiny, her godparents' cat.

www.racheldevine.com

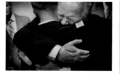

© Frank DiMeo

(p. 36) Rodney Adams embraces his newly married son, Ben, in upstate New York, USA.

www.frankdimeo.com

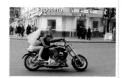

© Armen Dolukhanyan

(p. 138, below) A newly married couple takes to the streets of Kharkov, Ukraine.

www.armendolukhanyan.com

© Pamela Duffy

(p. 90) Hana the bride is captured with her family: father, mother, brother, best friend, and Akasha the dog who acts as ring bearer.

www.pameladuffyphoto.com

Jodi Durow
USA

A former opera singer, Jodi Durow now works as a family and children's photographer in Potsdam, New York, USA. She still sings to clients to make them laugh and break the ice.

Lene Ebbensgaard
DENMARK

Having graduated from the Danish School of Journalism as a photojournalist, Lene Ebbensgaard now works as a freelance photographer for one of Copenhagen's daily newspapers, as well as the *Birmingham Post* in the UK.

Philipp Engelhorn
HONG KONG

Born in the Black Forest of southern Germany, Philipp Engelhorn worked as a photographer's assistant in New York, USA, before relocating to Hong Kong. His specialties are reportage, travel, and portrait photography.

Edith Eussen
NETHERLANDS

Edith Eussen studied photography at the St Joost Academy of Fine Arts in Breda, Netherlands, and now works as a portrait and landscape photographer in Heerlen. Her work has been exhibited regularly in her own country.

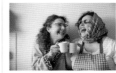

Lorna Fitzsimons
IRELAND

Lorna Fitzsimons is an international commercial photographer whose work has appeared in countless publications. She has exhibited widely in solo and group shows and directed television commercials and several short films. She lives in Dublin, Ireland.

© Jodi Durow

(p. 66) The photographer's friend, Caroline, has finally managed to get her three-week-old daughter, Catherine, off to sleep.

www.jodidurowphotography.com

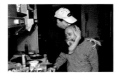

© Lene Ebbensgaard

(p. 41) Niels and Peder, both residents of a shelter for homeless men in Copenhagen, Denmark, share an affectionate moment.

www.lefoto.dk

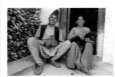

© Philipp Engelhorn

(p. 135, above) In northwest Nepal, Aita and Bishnu pose with their favourite pets: monkey Mickey and puppy Banjo.

www.philippengelhorn.com

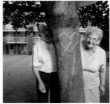

© Edith Eussen

(p. 161) This couple in Geleen, Netherlands, has been married for sixty years. The building in which they live (seen in the background) was the school which the husband attended as a child, and they are standing in what was once the school playground.

www.edith-eussen.nl

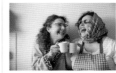

© Lorna Fitzsimons

(p. 58, below) In Ireland, on an afternoon in spring, Mary and Lorna share a cup of tea and a laugh.

www.lornafitzsimons.com

Genevieve Fridley
USA

A professional photographer based in Syracuse, New York, USA, Genevieve Fridley specializes in documentary images of families and weddings.

Jenny Gay
USA

Being included in this book is Jenny Gay's first major photographic achievement.

Martina Gemmola
USA

Australian photographer Martina Gemmola lived and worked in Greece before moving to Los Angeles, California, USA, where she continues her freelance career.

Alan Gignoux
LEBANON

Originally a documentary researcher and journalist, Alan Gignoux now works as a reportage photographer. He travels the world to photograph people displaced by natural disasters, conflict, and racial segregation.

David Graham
UK

London-based David Graham completed an MA in photojournalism after his son became paralysed in 2005. He is the founder of the charity Changing Ideas, which works with NGOs to make a difference using photography.

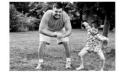

© Genevieve Fridley

(p. 163, below) Will and his seven-year-old son, Andrew, flex their muscles at a summer party in Fayetteville, New York.

www.genphotos.com

© Jenny Gay

(p. 166) In Lakewood, Colorado, USA, Kam and Jaden share a bath after a long day at the zoo.

www.jengay.com

© Martina Gemmola

(p. 157) Kyria, an elderly villager from Messinia, Greece, laughs in front of the camera.

www.gemmola.com

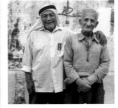

© Alan Gignoux

(p. 31) Two old friends who both served in the Palestine Police Force spend time together at Wavel refugee camp in Baalbeck, Lebanon.

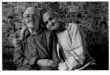

© David Graham

(p. 134, below) Daniel, an artist, and his wife, Vera, pose in their bedroom in their flat in Krivoy Rog, Ukraine. The walls are covered with pictures that have been cut out by Daniel.

www.photograhams.com

Mark Hanauer
USA

A native Californian, Mark Hanauer specializes in taking photographs for the advertising, entertainment, editorial, and athletics industries. He was the chief photographer for A&M Records and has taught at Art Center College of Design and UCLA.

Alicia Hansen
USA

Alicia Hansen has worked as a photojournalist and photo editor for newspapers and magazines, taught photography at undergraduate and graduate levels at Syracuse University and now works as a freelance photographer in New York City, USA, where she also runs a non-profit organization called nycSalt, which teaches photography to inner-city children.

Caroline Hayeur
CANADA

A member of the collective Agence Stock Photo in Montreal, Quebec, Canada, Caroline Hayeur began her photographic career with a series on the Montreal rave and techno scenes. She has exhibited in Mexico, China, Europe, Asia, and South America.

Isabelle Heyvaert
BELGIUM

Isabelle Heyvaert studied photography at night school in Ghent and considers it a hobby, although she often takes pictures for *knokkestyle* magazine. Her favorite subjects are her twin sister Veronique and Veronique's children.

Lionel Hug
FRANCE

Lionel Hug was born in Arles, France, and studied photography in Paris. He has taken theatre photographs for the press, worked for a photo laboratory, and undertaken photographic projects abroad. He now works as a freelance photographer.

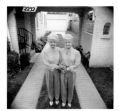

© Mark Hanauer

(p. 72) Identically dressed Shirley and Virginia pose for their portrait at their home in Santa Monica, California, USA.

www.markhanauer.com

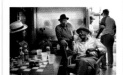

© Alicia Hansen

(p. 26) Long-time friends relax in a bar on Auburn Avenue in downtown Atlanta, Georgia, USA.

www.aliciahansen.com

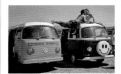

© Caroline Hayeur

(p. 160) A kissing couple marks the end of a three-day camp for pre-1979 Volkswagen buses, held on the sand dunes at Tadousac on the shores of the St Lawrence River, Quebec, Canada.

www.agencestockphoto.com

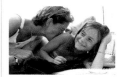

© Isabelle Heyvaert

(p. 100, above) Veronique and Kelly share a mother-daughter moment on the beach in Het Zoute, Belgium.

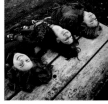

© Lionel Hug

(p. 164) The photographer's daughters, Elisa and Manon, and their friend, Chloe, pose for a photo on the way home from a walk in Thiré, their home village in Vendée, France.

www.lionelhug.photography.artlimited.net

Kathleen Hunter
USA

Kathleen Hunter lives in Chapel Hill, North Carolina, USA, and specializes in children's and nature photography.

Christian Inocencio
PHILIPPINES

An amateur photographer, Christian Inocencio has been successful in photography-club competitions in the Philippines, but considers his inclusion in this book his biggest achievement to date.

Cheryl Jacobs Nicolai
USA

Based in Denver, Colorado, USA, Cheryl Jacobs Nicolai is self-taught and works only with black-and-white film. Her photographs have been featured in magazines and exhibitions in Canada and the USA.

Jonathan Jones
UK

Jonathan Jones is a freelance photographer based in Torquay, Devon, UK.

Wayne Jones
AUSTRALIA

Having learned the basics of photography at night school and in the army, Wayne Jones went on to work for newspapers and magazines in the fields of hard news, sport, and human interest.

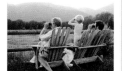

© Kathleen Hunter

(p. 83) Fresh from his bath, his towel discarded, Thomas joins his father, Jack, and grandpa, Ross, in a spot of bird watching while on holiday in Jackson Hole, Wyoming, USA.

www.kathleenhunterphotography.com

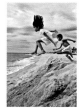

© Christian Inocencio

(p. 51) Local children enjoy the simple pleasures of the seashore in the Philippines province of Zambales, which was once devastated by the eruption of Mount Pinatubo.

www.inokalbo.multiply.com

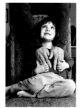

© Cheryl Jacobs Nicolai

(p. 76) In Littleton, Colorado, USA, Sophia gazes up at her Grandpa Tracy.

www.cherylnicolai.com

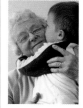

© Jonathan Jones

(p. 101) The photographer's son, Oliver, and his grandma express their affection for each other.

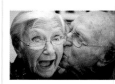

© Wayne Jones

(p. 135, below) Jean and Ron from the Gold Coast, Australia, who met as teenagers and were then separated by war, show affection on their sixty-fifth wedding anniversary.

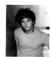

Jonas Jungblut
USA

Jonas Jungblut was born and raised in Berlin, Germany, but now lives and works in Santa Barbara, California, USA.

© Jonas Jungblut

(p. 145) In Santa Barbara, California, USA, one-year-old Keean and his father, Marcus, play a game that involves Keean being tossed on to a bed piled with blankets.

www.jonasjungblut.com

Edis Jurčys
USA

After graduating as a director of photography from the Moscow Film Institute, Edis Jurčys worked in Russian television before leaving for the USA, where he still lives. He now works as a fine-art and commercial photographer, and as a documentary cameraman.

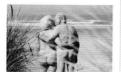

© Edis Jurčys

(p. 138, above) The photographer's mother-in-law is photographed with her new boyfriend on the Oregon Coast, Oregon, USA.

© Edis Jurčys

(pp. 174–175) On a windy day in Ireland, three ladies work hard to light their cigarettes.

John Kaplan
USA

John Kaplan is one of the USA's most accomplished photographers, having been awarded the Pulitzer Prize for Feature Photography and many other awards.

© John Kaplan

(p. 40) This self-portrait documents the return of John Kaplan to his class at the University of Florida, USA, after chemotherapy treatment for non-Hodgkin's lymphoma.

www.johnkaplan.com

Thomas L. Kelly
NEPAL

Born in Santa Fe, New Mexico, USA, and educated in Chicago and Rome, Italy, Thomas L. Kelly first went to Nepal in 1978 as a USA Peace Corps volunteer. He now works as a photo-activist, documenting the struggles of marginalized people and disappearing cultural traditions all over the world. He has produced and directed films and videos, published photographic books, and currently educates young people on how to use the media to express their concerns.

© Thomas L. Kelly

(Case and pp. 4–5) Makuna school children share a happy moment at Manaitara Island in the Colombian Amazon.

www.thomaslkellyphotos.com

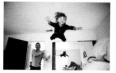

Greg Kessler
USA

Greg Kessler's photographs have appeared in publications such as O, The Oprah Magazine, Newsweek, Rolling Stone, Vogue, and the New York Times.

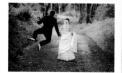

© Greg Kessler

(p. 115) Brooklyn couple Liz and Sean set out on their married life in Killarney, Ireland.

www.gregkessler.com

Zaven Khachikyan
ARMENIA

After studying physics and philosophy at Yerevan State University, Zaven Khachikyan took up freelance photography. His work has been published in local and international magazines, and he has held exhibitions both at home and abroad.

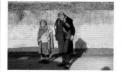

© Zaven Khachikyan

(p. 58, above) In Armenia's Gegharkunik province, two women are on their way to a neighboring village to celebrate the birth of another child in the family.

Julia Komissaroff
ISRAEL

Specific areas of interest to Julia Komissaroff are the Israeli-Palestinian conflict and countries of the former Soviet Union, both of which are reflected in her photography. She works with an Arab-Jewish human rights organization, Taayush, as well as with the Norwegian Refugee Council.

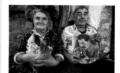

© Julia Komissaroff

(pp. 98–99) Winemaker Sandro and his wife hold treasured possessions at their home in the village of Caspi, Georgia.

www.komissaroff.com

Maaike Koning
NETHERLANDS

Maaike Koning studied art in The Hague and now lives in Amsterdam, Netherlands, where she works as a portrait and social-documentary photographer.

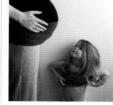

© Maaike Koning

(p. 86) The photographer and her two-year-old daughter, Sam, compare baby bellies. Three weeks after this picture was taken, Maaike's son, Sverre, was born at home in Amsterdam.

www.maaikekoning.nl

Anna Kuperberg
USA

A documentary and wedding photographer based in San Francisco, USA, Anna Kuperberg has a BFA from Washington University and an MFA from the San Francisco Art Institute.

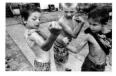

© Anna Kuperberg

(pp. 28–29) Young boys compare their muscles in a working-class neighborhood on the south side of St Louis, Missouri, USA.

www.kuperberg.com

Tanya Lake
AUSTRALIA

Tanya Lake studied photography as part of a journalism degree at Newcastle University and in Sweden, and has spent the last ten years working as a freelance photographer in Sydney for newspapers, magazines, and non-government organizations. She has undertaken assignments in Papua New Guinea, Malawi, Tanzania, Burma, and Tahiti.

Martin Langer
GERMANY

Martin Langer was born in Göttingen, Germany, and studied in Bielefeld. An award-winning freelance photographer, he lives and works in Hamburg.

Ricardo Leal
PORTUGAL

Born in Viseu, Portugal, Ricardo Leal studied architecture at the University of Porto. He is currently studying for his diploma thesis through the AHO (Oslo School of Architecture and Design) in Oslo, Norway.

Jean-François Leblanc
CANADA

In 1987, Jean-François Leblanc founded the collective Agence Stock Photo in Montreal, Canada, and works as an independent press photographer and photojournalist. He has held exhibitions in Montreal, Mexico, Haiti, and France.

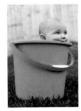

© Tanya Lake

(p. 94) Ensconced in her bucket, four-month-old Indigo supervises the washing being hung out in her backyard at Maroubra Beach, New South Wales, Australia.

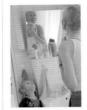

© Martin Langer

(p. 64) Four-year-old Emma mimics her grandfather, Alfred, as he shaves at his home in Göttingen, Germany.

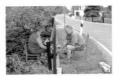

© Martin Langer

(p. 121) A couple in Kroptewitz, Germany, paint both sides of a fence at the same time.

www.langerphoto.de

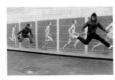

© Ricardo Leal

(p. 144) Best friends Toni and Foyedo have a tradition of being photographed while jumping. Here they are on a student trip to architect Tony Garnier's Le quartier des États-Unis in Lyon, France.

www.flickr.com/photos/faller_man

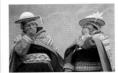

© Jean-François Leblanc

(pp. 168–169) Felicidad and her friend are members of the Kallawaya community in Curva, Bolivia, which is known for its holistic medicine. They have just celebrated a spiritual ceremony and are wearing traditional clothing.

Andrew Lichtenstein
USA

New York City–born Andrew Lichtenstein is a photographer based in Brooklyn, New York, USA.

Sam Lim
MALAYSIA

Sam Lim works as an advertising and promotions manager in a jewellery factory where his job includes design and photography for catalogues and brochures. He was inspired to become a photographer by some postcards of sunsets, which he saw when visiting a bookshop when he was still at school.

Karin Lindén
SWEDEN

After living in the USA and the UK, Karin Lindén returned to her homeland of Sweden. She specializes in taking wedding, child, and family portraits. Her two daughters are frequent subjects.

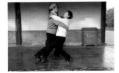

© Jean-François Leblanc

(p. 134, above) Prohibited during Mao's political regime, the tango is now popular in China and a couple is free to practise the dance in a Beijing park.

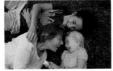

© Andrew Lichtenstein

(p. 100, below) Three generations—mother, Linda, daughter, Jade, and grandmother, Sharon—share an affectionate moment on a late-summer afternoon in New Hampshire's White Mountains, Western Maine, USA.

www.lichtensteinphoto.com

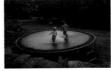

© Andrew Lichtenstein

(pp. 178–179) Two-year-old Jade and four-year-old Adrian make good use of a friend's trampoline in the last of the evening light in Western Maine, USA.

www.lichtensteinphoto.com

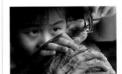

© Sam Lim

(p. 126) The photographer's son, Lim-Kenji, clips his grandmother's fingernails.

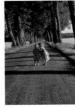

© Karin Lindén

(p. 32) In the late summer evening, Tuva and Tintin make their way home through the Swedish countryside.

www.lonnbackafotograferna.se

Jean Lopes
BRAZIL

Jean Lopes is a self-taught photographer who works as a freelancer in Brazil, Argentina, Austria, and Colombia. He has twice won the Leica-Fotografe, one of the most important photography contests in Latin America.

Anders Ludvigson
SWEDEN

A photographer for thirty years, Anders Ludvigson, from Leksand, Sweden, concentrates on taking pictures of nature, culture, and traditional ways of life.

Melissa Lyttle
USA

After graduating from the University of Florida with a degree in journalism, Melissa Lyttle worked for a local newspaper before being hired as a staff photojournalist at the *St Petersburg Times*.

Richard Magee
NORTHERN IRELAND

A qualified mountain leader with a degree from Glasgow University in outdoor education, aspiring amateur photographer Richard Magee hopes to become an expedition photographer and combine his two favorite pastimes.

Lisa Maksoudian
USA

An award-winning commercial and portrait photographer, Lisa Maksoudian specializes in on-location children's work. Having lived in Prague, Czech Republic, and Western Europe for two years, she found her way home to the town of San Luis Obispo, California, USA.

© Jean Lopes

(p. 153) Ponta do Mel, a beach in north-eastern Brazil, is the setting for a tug-of-war between a little girl and a dog.

www.jeanlopes.com

© Anders Ludvigson, LudvigsonBild

(Endpapers) This graffiti-covered wall is in a little old house on a pier in Leksand, Sweden, where passengers wait for a boat to take them on the lake.

www.ludvigsonbild.se

© Melissa Lyttle

(p. 67) Nine-year-old Dani receives affection from her adoptive father in Fort Myers, Florida, USA.

© Richard Magee

(pp. 186–187) This graffiti-covered passage-way leads to Juliet's House in Verona, Italy, immortalized by Shakespeare in *Romeo and Juliet*.

© Lisa Maksoudian

(p. 1) Eight-year-old identical twins in southern California, USA, play together on a balmy summer evening.

www.lisamaksoudian.com

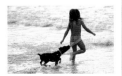

Katarzyna Mala
POLAND

Katarzyna Mala is a freelance photographer who works for a national newspaper. She has previously been associated with Reuters and the Associated Press as well as a Polish news photo agency.

John Marechal
CANADA

Based in Hamilton, Ontario, Canada, John Marechal has specialized for thirty years in photographing wildlife and nature subjects, particularly birds and butterflies.

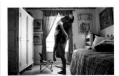

Nigel Marrington
UK

Nigel Marrington lives in London, UK, and for most of his life has worked to provide housing and support for homeless people. He is interested in candid and wide-angle photography.

Vladimir Melnik
RUSSIA

Working as a freelancer, Vladimir Melnik specializes in travel photography and is particularly interested in taking pictures of people in remote areas.

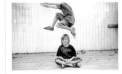

Abraham Menashe
USA

Although born in Egypt, Abraham Menashe now lives and works in New York, USA. He is the author of nine books and his work is represented in several museum collections, including New York's Museum of Modern Art and Metropolitan Museum of Art.

© Katarzyna Mala

(p. 73) In Warsaw, Poland, the photographer's goddaughter, Hania, embraces her great-grandmother, Maria, whose portrait hangs behind them.

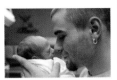

© John Marechal

(pp. 80–81) In St Joseph's Hospital in Hamilton, Ontario, Canada, the photographer's son, Chris, holds his own son, Seth. Born prematurely, this is the first time Seth has been cuddled by his dad without being connected to a machine.

www.critterpix.ca

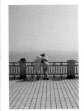

© Nigel Marrington

(p. 108) On a hot weekend in August, above the cliffs at Folkestone, Kent, UK, a couple gazes across the sea to France.

www.nigelmarringtonphotography.com

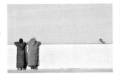

© Vladimir Melnik

(pp. 118–119) A comradely moment is shared on the seafront at Essaouira in Morocco.

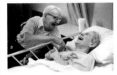

© Abraham Menashe

(pp. 38–39) This married couple met in a nursing home. The wife, who is paralyzed, shares a joke with her husband.

www.humanistic-photography.com

Melissa Mermin
USA

Although she started out in college as a fine-art painter, Melissa Mermin decided she preferred photojournalism. At the age of twenty-four she photographed the wedding of her cousin as a gift, and since then has worked as a full-time wedding photographer.

Stephanus Meyer
SPAIN

Born to a Spanish mother and a South African father in Zambia when it was still a British colony, Stephanus Meyer lived in South Africa before settling in Spain in 1983. He began his photographic career when he was sixteen, and since then has won many awards.

Michael Meyersfeld
SOUTH AFRICA

Michael Meyersfeld took up photography after his family's steel merchandising business was sold, and he now works professionally in both the commercial and fine-art fields. He has exhibited nationally and abroad and his work is represented in the Johannesburg Art Gallery.

Elton Mogg
UK

Elton Mogg is a professional wedding and portrait photographer who works throughout the UK and Europe.

© Melissa Mermin

(pp. 70–71) On her wedding day, the bride, Jessica, hugs her mother whose own wedding portrait hangs above the mantelpiece in her home in North Stonington, Connecticut, USA.

www.melissamermin.com

© Melissa Mermin

(p. 109) Newlyweds Eileen and Jim Wrubel collapse on to their hotel bed in Boston, Massachusetts, USA.

www.melissamermin.com

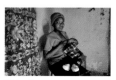

© Stephanus Meyer

(pp. 16–17) A young single mother takes a break to feed her baby. She is a farm worker in the Karoo region, South Africa.

www.stephanusmeyer.com

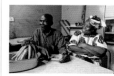

© Michael Meyersfeld

(pp. 128–129) A couple share an amusing moment in Alexandra Township, near Johannesburg, South Africa.

www.meyersfeld.com

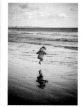

© Elton Mogg

(p. 154) The photographer captures his two-year-old daughter Rheya's excitement at being at her favorite place: the beach at The Witterings in West Sussex, UK.

www.eltonmogg.co.uk

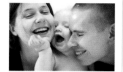

Fran Monks
UK

Fran Monks's first career was as an environmentalist for a multinational oil company. She retrained in London, UK, and Washington, DC, USA, and now works as a freelance portrait photographer.

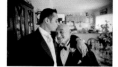

Graham Monro
AUSTRALIA

With work published in nearly all the major Australian magazines, Graham Monro is the founder of wedding and portrait studio GM Photographics.

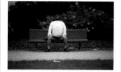

Javad Montazeri
IRAN

After graduating with a degree in photography from Azad University of Art in Tehran, Iran, Javad Montazeri worked as a photographer and photo editor for many Iranian magazines and newspapers and as a freelance photographer for Reuters. He is now based in New York, USA, and works for international photo agencies.

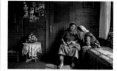

Bob Moore
UK

An engineering apprentice before taking up photography in his late teens, Bob Moore has been a lecturer and course organizer in the photographic retail industry for the past thirty years. He is a past president of the Royal Photographic Society.

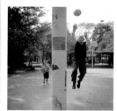

Silvia Morara
ITALY

After graduating with a degree in philosophy from Bologna University, Silvia Morara spent a year as a photojournalist on a local newspaper before following international news stories in hot spots such as Israel, Palestine, Pakistan, Afghanistan, and the former Yugoslavia. Working as a freelance photo reporter, she has shot documentaries in several African countries.

© Fran Monks

(p. 97) Gaylea and Brant play with their son, Abraham, at home in Washington, DC, USA.

© Graham Monro

(p. 37) Bridegroom Vince shares a pre-wedding moment with his father, Giuseppe, at the family home in Auburn, Sydney, Australia.

© Javad Montazeri

(p. 120) A pair of lovers is entwined on a seat on the Avenue des Champs-Élysées in Paris, France.

www.javadmontazeri.com

© Bob Moore

(p. 136) Two friends catch up on the local gossip at home in northeast Turkey.

© Silvia Morara

(p. 19) A small boy and his grandfather play basketball in a park in Milan, Italy.

www.silviamorara.it

Tara Morris
CANADA

Tara Morris photographs children and families from her base in Penticton, British Columbia, Canada.

Fiona Morrison
AUSTRALIA

Growing up in Melbourne, Australia, Fiona Morrison was given her first camera when she was six, and soon learned to print her own images in her father's home darkroom. She now lives and works in Darwin.

Reg Morrison
AUSTRALIA

Reg Morrison has worked in Western Australia as a journalist and news photographer, and for a Sydney book publisher. In 1983, he compiled a book on Australia's evolution and has specialized in environmental and evolutionary matters ever since.

Saikat Mukherjee
INDIA

A language teacher from Ranaghat, West Bengal, India, Saikat Mukherjee seriously took up photography in late 2006, having previously been most passionate about creative writing. In his work, he captures a range of images depicting life in India.

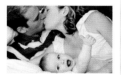

© Tara Morris

(p. 150) Mother, father and six-month-old son share an intimate moment in Kelowna, British Columbia, Canada.

www.taramorrisphotography.com

© Fiona Morrison

(p. 65) The photographer's two-year-old daughter, Mahli, makes friends with Holly, a visitor newly arrived in Darwin, Australia.

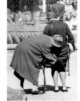

© Reg Morrison

(p. 47) Old friends check each other's grooming in Hyde Park, Sydney, Australia.

© Reg Morrison

(p. 151) In Sydney, Australia, the photographer's daughter, Danielle, is ready to be breastfed.

© Saikat Mukherjee

(p. 155) Two boys run into the surf in Digha, a coastal town in West Bengal, India.

Maggie Murray
UK

Maggie Murray lives in London, UK, and has traveled widely as a freelance photojournalist. Her work has appeared in books, magazines, teaching packs, and exhibitions. She was a founder member and partner in Format, the only women's photography agency in the UK.

Birgit Neiser
GERMANY

After gaining a degree in economics from Freiburg University in Germany, Birgit Neiser studied photography in the United States. She has published several books and exhibited her work in galleries in Sydney, Australia, and Munich, Germany.

Ron Nicolaysen
USA

A fine-art and commercial photographer, Ron Nicolaysen has had work published in fashion and science magazines, held exhibitions throughout Italy, and published several books. He is currently working on a project for the United Nations.

Paul O'Connor
UK

After studying at the Salisbury College of Art where he won several awards, Paul O'Connor has worked as a freelance photographer in the worlds of editorial, design, and advertising.

Andy Palmer
UK

Since graduating with a degree in photography, Andy Palmer has worked as both a freelance photographer and staff member for regional and national press in the UK.

© Maggie Murray

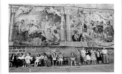

© Birgit Neiser

© Ron Nicolaysen

(p. 54) Two friends enjoy a summer evening in each other's company outside their house in Majorca, Spain.

www.nicolaysen.com

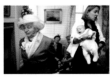

© Paul O'Connor

(p. 91) Guests, Ivy, Sarah, and baby Harry, are captured at a wedding in Wiltshire, UK.

www.paul-oconnor.com

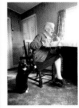

© Andy Palmer

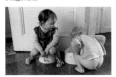

© Maggie Murray

(p. 56) In London, UK, two-year-old playmates are photographed using their potties.

(pp. 188–189) Toledo in Spain celebrates the religious festival of Corpus Christi every year when seventeenth-century tapestries are hung over the facade of the cathedral. Locals gather along the cathedral wall, waiting for the procession to start.

www.photos-unlimited.com

(p. 46) Clara was a friend of the famous suffragettes, the Pankhursts. She lived alone at her home in Essex, UK, into her nineties, with her cat for company.

www.andypalmerphotography.com

Chantra Pramkaew
THAILAND

Chantra Pramkaew's passion for travel led to her interest in photography, and although photography was initially just a hobby, she is now an award-winning professional photographer.

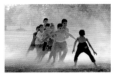

© Chantra Pramkaew

(p. 140) Children in the Chainat province in the north of Thailand play a traditional game called "chickens and the hawk."

Fabien Raes
BELGIUM

Fabien Raes has been a photographer for more than thirty years and has published books on Cuba and Beijing. He has worked for the Cannes Film Festival and as a magazine fashion photographer.

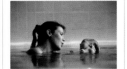

© Fabien Raes

(pp. 6–7) Sonja has just given birth in the water to her fourth child Manon at the Henri Serruys Clinic in Oostende, Belgium.

www.fabienraes.com

J.B. Russell
FRANCE

A photojournalist based in Paris, France, J.B. Russell's work is published regularly in newspapers, magazines, books, and on the internet. He has received numerous international awards.

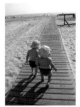

© J.B. Russell

(p. 59) Sisters Kassandra and Kallisto discover the ocean for the first time at Oliva Playa in Spain.

www.jbrussellimages.com

Davi Russo
USA

New York-based Davi Russo views the camera as an opportunity to meet, look and collaborate with people.

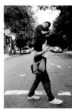

© Davi Russo

(p. 68) Koa's father, Jima, piggybacks her down Second Avenue in New York, USA.

Luis Sanchez Davilla
SPAIN

Since majoring in photojournalism at the Complutense University of Madrid, Luis Sanchez Davilla has traveled the world documenting international conflicts as well as photographing personalities from the cultural, artistic, and political worlds. In 1998, he was pictures editor for the Spanish edition of *Paris Match*, but now works as a freelance photographer.

© Luis Sanchez Davilla

(p. 33) Holy men contemplate the sunset in the Hanuman Temple, also known as Monkey Temple, in Hampi, India.

www.luisdavilla.com

Paolo Sapio
ITALY

Paolo Sapio is from Naples, Italy, and has been interested in graphics since he was eight years old. Specializing in digital photography, he is also a web designer with particular interests in fashion, advertising, and artistic photography.

© Paolo Sapio

(pp. 104–105) A self-portrait of the photographer's hands.

www.wadesign.it

Cleverson Sefrim
AUSTRALIA

Born in Brazil, Cleverson Sefrim traded studies in mechanical engineering for life in Japan, then moved to Southeast Asia. He is a self-taught photographer and currently lives in Australia.

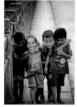

© Cleverson Sefrim

(p. 183) Children pose for the camera on a bridge in a small village in northern Laos.

Nico Sepe
SRI LANKA

Nico Sepe taught himself to be a photographer when he was sixteen, and documented lives in the underground movement during the latter years of the Marcos dictatorship. He continues to document social and political change, and has worked for newspapers, magazines, and on various book projects. He currently lives in Sri Lanka.

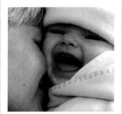

© Nico Sepe

(p. 149) The photographer's four-month-old daughter, Olivia, is cuddled by her mother, Maeve.

Moshe Shai
ISRAEL

Moshe Shai is a professional stills photographer who lives in Tel Aviv, Israel. He works in press, documentary, and geographical photography, is an exhibition initiator and curator, and an editor of photography books.

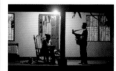

© Moshe Shai

(p. 106) A family spends a hot evening on their porch in Bluefields, a small port town on the east coast of Nicaragua.

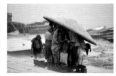

© Moshe Shai

(p. 180, below) Indian pilgrims waiting to wash away their sins in the Ganges, India, are caught in a monsoon on the riverbank at Varanasi.

Brian Smith
USA

Pulitzer Prize-winning photographer Brian Smith's portraits of celebrities, athletes, and executives have appeared on hundreds of magazine pages and covers over the past twenty-five years. Brian is president of an organization to which 2000 of the world's top magazine and news photographers belong. He lives in Miami Beach, Florida, USA.

Joyce Smith
USA

Previously a literature teacher and PhD student, Joyce Smith exchanged academia for photography in 2006, and now specializes in children's portraits.

Len Speier
USA

After the army, college, and law school, Len Speier took to the streets as a documentary photographer and worked in various parts of the world. He has recently retired as photography professor at the Fashion Institute of Technology in New York, USA.

Arne Strømme
NORWAY

Arne Strømme is a freelance photographer and landscape architect who lives in Molde, Norway. For the last ten years he has traveled around the world with his camera.

Piko Sugianto
INDONESIA

Piko Sugianto lives in Yogyakarta, Indonesia, where he studied photography and has held several exhibitions.

© Brian Smith

(p. 167) At Century Village, Florida, USA, friends Pauline and May have just come out of the pool after their water-aerobics class.

www.briansmithmiami.com

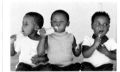

© Joyce Smith

(pp. 122–123) In Philadelphia, Pennsylvania, USA, young cousins set off down one of the city's old cobblestoned streets on their way to the playground.

www.joycesmithphoto.com

© Len Speier

(p. 89) The photographer's wife, Joan, and their son, Jonathan, at home in New York, USA.

© Arne Strømme

(p. 27) Sisters Randi and Aase share a joke on a nature walk in Romsdal, Norway.

www.arnestromme.no

© Piko Sugianto

(p. 125) This old lady sells vegetables every morning at the market in Klaten, Java, Indonesia.

www.pikosaw.deviantart.com

Pietro Sutera
GERMANY

Originally from Italy, but now based in Frankfurt, Germany, Pietro Sutera works on fine-art, advertising, and editorial assignments. His involvement with a German charitable organization regularly takes him to humanitarian projects all round the world.

© Pietro Sutera

(p. 62) Early morning teeth-brushing is a ritual for three little girls in a township near Cape Town, South Africa.

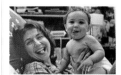

Sam Tanner
UK

Documentary photographer Sam Tanner works mostly for charities and NHS (National Health Service) trusts. Personal projects have included one on the Jewish community in the East End of London, and a study of the last ten years of the life of his mother who died at the age of ninety-seven.

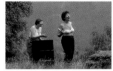

Jane Thérèse
USA

A freelance photographer with many awards and gallery exhibitions to her credit, Jane Thérèse's images have appeared in the *New York Times* and *Newsweek* and in publications in Tokyo and Paris.

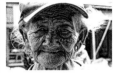

Lindsey Thompson
USA

Lindsey Thompson is an award-winning photographer who specializes in photographing children, and is inspired by her own family on a daily basis.

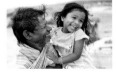

© Pietro Sutera

(p. 148) In Tamil Nadu, India, a little girl welcomes her father home from a long fishing trip.

www.pietro-sutera.de

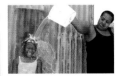

© Pietro Sutera

(pp. 84–85) A bucket of cold water makes a welcome shower on a hot day for a little girl in Cape Town, South Africa.

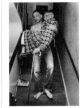

© Sam Tanner

(p. 127, left) A caregiver carries his elderly father down the stairs of their home in the UK.

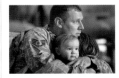

© Jane Thérèse

(p. 60) At the air force base in Willow Grove, Pennsylvania, USA, airman Jason Koder embraces his new wife and young son before he heads off for his third deployment to Afghanistan.

www.janetheresephoto.com

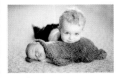

© Lindsey Thompson

(p. 165) Siblings Milas and Maren are photographed together in West Plains, Missouri, USA.

www.thompsonsphotography.com

Brandy Torvinen
USA

Brandy Torvinen lives in Michigan, USA, and specializes in children's portraiture.

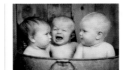

© Brandy Torvinen

Horia Tudor
ROMANIA

Horia Tudor was born in Brasov, Romania. He studied engineering, but began taking photography seriously after assisting his father, an avid amateur photographer. He divides his time between Brasov and Brussels, Belgium.

Victoria Vaisvilaite Skirutiene
LITHUANIA

Although Victoria Vaisvilaite Skirutiene has a university degree in history, studies psychology, and practises as an image designer, photography is her greatest passion. She lives in the seaport city of Klaipėda, Lithuania, with her husband and two young children.

WINNER OF THE GRAND PRIZE IN THE FRESH M.I.L.K. COMPETITION

Edward van Herk
NETHERLANDS

Taking up photography after he lost his son in 2003 was a way of dealing with grief for Edward van Herk. He now travels as an airline pilot and documentary photographer.

© Brandy Torvinen

(p. 152) Jack and Jed are photographed at Jack's house in Houghton, Michigan, USA.

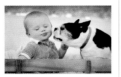

© Brandy Torvinen

(p. 95) Cousins Justin, Hanna and Austin find it too close for comfort in the tub in the photographer's studio.

www.brandytorvinenphotography.com

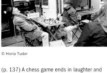

© Horia Tudor

(p. 137) A chess game ends in laughter and good cheer in a street in Brussels, Belgium.

© Victoria Vaisvilaite Skirutiene

(pp. 20–21) Two-year-old Mia is traveling with her family from Lithuania to Moscow in a camper van. Her father, Arunas, does his best to keep her entertained during a stop on the long journey.

www.vvphotography.eu

© Edward van Herk

(p. 163, above) In Nederhemert, Netherlands, eighteen-month-old Rijk, the photographer's second-born son, is engrossed in front of a computer, watching *Sesame Street*'s Big Bird.

www.edwardvanherk.com

Gerhard van Roon
NETHERLANDS

Gerhard van Roon studied applied physics before being admitted to the Royal Academy in The Hague to study photographic design. He employs his documentary style for both editorial and commercial assignments.

Vukasin Veljic
SERBIA

Born in Belgrade, Serbia, Vukasin Veljic began his career as a photo reporter on a daily newspaper, then enrolled in the camera department of the Faculty of Dramatic Arts at the University of Arts in Belgrade to study as a director of photography.

Meg Venter
USA

Meg Venter is a fledgling photographer and full-time mother who lives in San Diego, California, USA.

Angela Vicedomini
SWITZERLAND

Born in Germany, raised in the Italian part of Switzerland, and having lived and worked for twenty-two years in Mauritius, Angela Vicedomini again lives in Switzerland. She became seriously involved in photography when she bought her first SLR camera in 2006.

Victoria Vincent
NEW ZEALAND

Victoria Vincent, a mother and photographer, lives and works in Wellington, New Zealand. She has been taking photographs since she was a young girl.

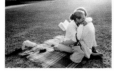

© Gerhard van Roon

(p. 117) On a spring Saturday in Hyde Park, London, UK, a couple relaxes while reading the third Harry Potter book.

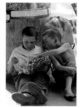

© Vukasin Veljic

(p. 57) Two cousins are engrossed in a magazine in a street market in central Belgrade's Terazije Square, Yugoslavia.

© Meg Venter

(p. 23) The photographer and her baby daughter, Wren, play in their living room.

www.septemberwren.com

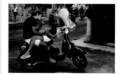

© Angela Vicedomini

(p. 114) Young lovers take to the streets of Mondello, Palermo, in Sicily, Italy.

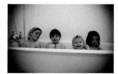

© Victoria Vincent

(pp. 92–93) Cousins Claudia, Max, Stella, and Holly take a bath together in Wellington, New Zealand.

www.victoriavincent.com

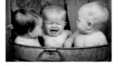

Dragomir Vukovic
USA

Born in Zemun, Serbia, Dragomir Vukovic has lived in Portland, Oregon, USA, for the last two years. He has been a systems engineer, massage therapist, chef, DJ, and health-food counselor as well as a photographer.

Stacy Wasmuth
USA

Stacy Wasmuth lives in Indianapolis, Indiana, USA, where her studio, Blue Candy Photography, creates artwork for portrait and commercial clients.

Stewart Weir
NETHERLANDS

Stewart Weir is a freelance documentary photographer whose work has appeared in newspapers, magazines, books, and exhibitions throughout the UK. He has self-published one book and co-authored another.

© Stewart Weir

(p. 130)

David White
UK

A professional photographer and photojournalist for twenty years, David White mainly shoots reportage and documentary subjects which he finds and researches himself. He has traveled the world for major international magazines and has won a World Press Award.

© Dragomir Vukovic

(pp. 78-79) In Dobanovci Cemetery in Serbia, the photographer's father, Radovan, grieves at the grave of his wife, Zorka. They were together for fifty-five years.

www.fotocommunity.com

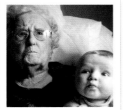

© Stacy Wasmuth

(p. 88) Wearing remarkably similar expressions, Evelyn and her great-grandson, Micah, meet for the first and last time at Evelyn's nursing home in Chillicothe, Ohio, USA.

© Stewart Weir

(pp. 2-3, 130, 131) A long-term study of Brighton Beach, UK, that was shot between 2001 and 2008 includes lovers kissing in the sea during an August downpour, a young couple embracing on the beach and friends looking out to sea.

© Stewart Weir

(pp. 131)

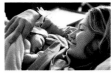

© David White

(pp. 74-75) Photographed in Bristol, UK, the photographer's wife sees their two-minute-old son, Louie, for the first time.

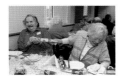

Charlotte Wiig
UK

Based in London, UK, Charlotte Wiig works as a freelance photographer and photojournalist for a variety of publications, both in the UK and internationally, as well as for commercial and public relations clients.

© Charlotte Wiig

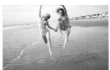

Elise Willingham
USA

A high-school student in Newburyport, Massachusetts, USA, Elise Willingham has been interested in photography since she was ten, and is active in her school's arts and photo programmes. She plans on going to art school when she graduates.

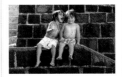

Terry Winn
NEW ZEALAND

Terry Winn ran a photography studio in Auckland, New Zealand, for more than twenty years, but now works from Havelock North. As well as undertaking national and international commissions, he has produced books, greeting cards, and calendars and has exhibited at Te Papa, New Zealand's national museum in Wellington.

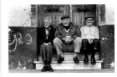

Todd Winters
USA

Todd Winters is an award-winning Chicago-based photographer whose editorial, corporate, and advertising assignments have taken him from Colombian jungles to South Korean medical laboratories.

© Charlotte Wiig

(pp. 172, 173) Seniors at a Christmas party held just outside London, UK, celebrate in the traditional way.

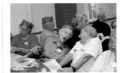

© Charlotte Wiig

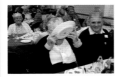

© Charlotte Wiig

© Elise Willingham

(p. 55) On the first day of summer it is still too cold for swimming, but friends Caroline and Taylor keep warm on the beach by jumping.

© Terry Winn

(p. 181) Hiwa and Terawai play on the steps leading to the beach at Pt. Chevalier in Auckland, New Zealand.

© Todd Winters

(pp. 24-25) Three lifelong friends enjoy Sunday afternoon on a stoop in Buenos Aires, Argentina.

www.toddwintersphoto.com

Tommy Wøldike
DENMARK

Tommy Wøldike is an athletics and swimming instructor who has enjoyed photography as a hobby for forty years, and won a number of awards for his images.

Ana Yturralde
SPAIN

Ana Yturralde specializes in photographing people. She has worked for various publications in Spain, and has held exhibitions in Spain, Senegal, and Nicaragua.

Iva Zímová
CANADA

Originally from the Czech Republic, Iva Zímová has lived and worked in Canada since 1982 where she studied photography. She has received grants to photograph Czech minorities in Romania and the native people of northern Quebec, Canada. Her work has been exhibited in many countries.

© Tommy Wøldike

(p. 116) Stefan and his girlfriend, Camilla, share a relaxed moment.

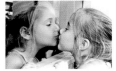

© Ana Yturralde

(p. 147) Twins Paula and Alba mirror each other's movements through a window in Valencia, Spain.

www.anayturralde.com

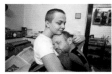

© Iva Zímová

(p. 44) Kacka and Josef embrace in their two-room apartment in Prague, Czech Republic.

www.ivazimova.com

First published in the United States in 2010 by
PQ Blackwell in association with Chronicle Books LLC.

Concept and design copyright © PQ Blackwell Limited 2009
Published under licence from M.I.L.K. Licensing Limited
Copyright © 2009 M.I.L.K. Licensing Limited. All rights reserved
The M.I.L.K. logo is copyright © M.I.L.K. Licensing Limited

Book design by Cameron Glbb

Library of Congress Cataloging-in-Publication Data available.

ISBN: 978-0-473-16417-1

Manufactured in China

Produced and originated by PQ Blackwell Limited
116 Symonds Street, Auckland, New Zealand
www.pqblackwell.com

10 9 8 7 6 5 4 3 2 1

Chronicle Books LLC
680 Second Street
San Francisco, California 94107
www.chroniclebooks.com

www.freshmilkphotos.com